HIDDEN
HISTORY
of
OLD
CHARLESTON

HIDDEN
HISTORY
of
OLD
CHARLESTON

Margaret Middleton
Rivers Eastman

with
EDWARD FITZSIMONS GOOD

THE
History
PRESS

Published by The History Press
Charleston, SC 29403
www.historypress.net

First published 2010
Second printing 2010
Third printing 2011
Fourth printing 2012

Manufactured in the United States
ISBN 978.1.59629.843.9

Library of Congress Cataloging-in-Publication Data

Eastman, Margaret M. R.
Hidden history of old Charleston / Margaret Middleton Rivers Eastman
with Edward FitzSimons Good.
p. cm.
Includes bibliographical references and index.
ISBN 978-1-59629-843-9
1. Charleston (S.C.)--History. 2. Charleston (S.C.)--Biography. 3.
Women--South Carolina--Charleston--Biography. I. Good, Edward
FitzSimons. II. Title.
F279.C457E35 2010
975.7'915--dc22
2010004105

In loving memory of our grandmothers
and
to our children and grandchildren,
for whom this book was written.

CONTENTS

Acknowledgements

Dorothy Middleton Anderson for photographs and research on the Anderson clan.

Marie Ferrara, Anne Bennett, Angela Flenner, Claire Fund, Deborah Larsen, John White and the College of Charleston Special Collections Library for providing a repository for Anderson, Barnwell, FitzSimons, Good, Middleton, Rivers and Trott family documents and digitizing photo collections.

Carl Borick, assistant director; Jennifer Scheetz, archivist; and Jan Hiester, registrar, of The Charleston Museum for invaluable assistance.

Angela Mack and Joyce Baker for the Henry Jackson painting at the Gibbes Museum of Art.

Michael Coker for identifying Louis F. Emilio.

Lisa Pringle Farmer for information about Nell Pringle and her family.

Charles W. Waring III for insights on Daisy Breaux's life and times.

Maurice Thompson for research about 54 King Street.

The Reverend Dr. William P. Rhett and Reverend Grayson B. Garvin for the St. Michael's Alley ghost story.

Carlton Simons and Mary B. Wilson for information on 4 South Battery.

Richard Donohoe for editing and photography.

Sarah Royall Gregorie Miller for Gregorie family pictures.

Thomas Pinckney Lowndes Jr. for the *New York Times* article about breaking the Union code.

Kathy Hughes for editing.

Laura All, Hilary McCullough, Jaime Muehl, Natasha Momberger, Julie Scofield, Emily Navarro, Julie Foster, Jamie Barreto, Katie Parry and the rest of the wonderful crew at The History Press.

Others who helped along the way: Charles J. Baker, David Barron, Frank Barron, Moultrie Burns, Amelia P. Cathcart, Hayes Anderson Fordney, Caroline McGregor Good, Henry Hutson, Catherine FitzSimons Lazenby, Christopher Metts, Greg Pearce, Vida FitzSimons Robertson, Cambridge Trott and Alice Whitt.

Seabrook Wilkinson for helping with the second edition.

Preface

This volume is a collection of tales that were passed on as part of a cherished inheritance. Some information has already appeared elsewhere, but as telecommunication devices replace the gentle art of conversation, these stories are becoming lost. We heard them from our grandmothers and their friends, who were a remarkable generation of ladies.

Mabel Olivia Trott lived in Mount Pleasant at the turn of the century. She was the daughter of Cambridge Munro Trott and Anne Gregorie. She had two sisters, Mary and Etta, and three brothers, Cambridge, Joseph and Henry. Anne Gregorie was the daughter of Ferdinand Gregorie and Anne Venning. Their harrowing experience is one of the chapters in this volume.

Mabel Trott attended Memminger School in Charleston. According to one graduate:

> *Memminger High School was a prison, physically and spiritually. We were severely restricted behind its high gray walls. I knew a girl who was suspended for waving to a boy over the wall. With few exceptions, our teachers were tired, aged maidens who dared not let us stray from dull texts. (Law prohibited married women from teaching.) Natural curiosity was discouraged. It was impertinent to ask, "What happened then?" The most galling feature of Memminger was the extra year that was tacked onto our curriculum. Boys attended school twelve years; we had to attend thirteen. Memminger had originally been a "normal" school for training teachers.* [1]

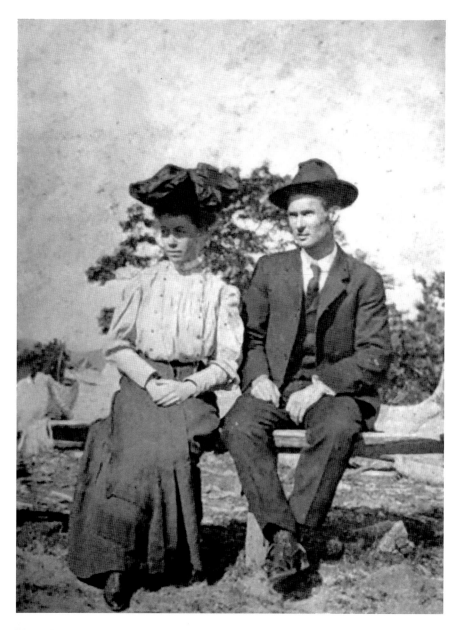

Mabel Trott FitzSimons and Waveland Sinclair FitzSimons. *Courtesy Edward F. Good.*

Mabel married Waveland Sinclair FitzSimons, a Citadel graduate who was employed by the U.S. Army Corps of Engineers. He participated in building the Intracoastal Waterway. This provided the FitzSimons family an opportunity to live in a kaleidoscope of interesting cities: Oswego, New York; Washington, D.C.; Boston, Massachusetts; Georgetown, South Carolina; and Miami and Fort Pierce, Florida.

Upon FitzSimons's retirement, the family returned to Charleston, where Mabel chronicled the histories of her ancestors and wrote *Hot Words and Hair Triggers*, an unpublished manuscript about dueling in South Carolina. Like many Charlestonians, Mrs. FitzSimons did not hesitate to write the newspaper about her opinions. She was a personal friend of Samuel Gaillard Stoney, the well-loved, eccentric College of Charleston professor. She is remembered as being somewhat self-centered and histrionic. Widowed, she lived with the Good family when she was elderly. She and her husband, Waveland, are buried in the Gregorie-Venning Cemetery in Mount Pleasant.

Jane Margaret Simons was also born just before the turn of the century and grew up at 1 Pitt Street in Charleston. After graduating from Memminger High School, she married Charles Francis Middleton III, son of a local cotton broker who worked in the family's business. After her children were raised, she became the foremost authority on colonial artist Jeremiah Theus. She wrote about Henrietta Johnston, America's first pastellist, and wrote a biography on David and Martha Laurens Ramsay, all after a bout with encephalitis and the tragic loss of her only son during World War II. Shortly before her death, she published a book about Aphra Harleston, who married John Coming, both of whom arrived in Charles Towne in 1670.

Margaret Middleton was a friend of Miss Sue Frost and served as the fourth president of the Society for the Preservation of Old Dwellings (now the Preservation Society). For her contributions to the community, she was presented the Roll of Honor by the Colonial Dames and was elected to the Hall of Fame by the Charleston Federation of Women's Clubs. She and her husband are buried in Magnolia Cemetery.

Although much of Margaret Middleton's research has been published, Mabel Trott's was left behind in unbound manuscripts and typed documents that were supplemented with scraps of paper scribbled with important afterthoughts. In time, these documents were given to her daughter, Mabel Good.

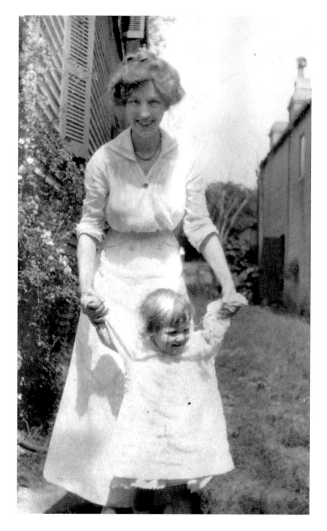

Margaret Simons Middleton with her daughter Marwee at 8½ Limehouse Street. *Courtesy Middleton Papers, College of Charleston Special Collections Library, Charleston, South Carolina.*

When Hurricane Hugo hit Charleston in 1989, the Goods were living at 4 Rutledge Avenue. Like many Charlestonians, they went to Columbia and remained there for over a month while the city recovered. The hurricane surge flooded their home with almost five feet of water. As they were elderly, their son drove in from Texas and commuted from Columbia each day to clean out the debris. It was a monumental task, for he found a jumble of overturned, water-laden belongings piled in complete disarray.

There was no electricity, and the summer heat had not yet given way to the cooler days of late October. Under extreme conditions, he salvaged what he could. Miraculously, Mabel FitzSimons's papers had been stored on a shelf scarcely a foot above the water line. Much of her priceless legacy is included in this volume.

As children, the authors were privileged to meet Miss Sue Frost and tour her lovely home on King Street. We hope that this volume has helped perpetuate the preservation legacy of the remarkable ladies of Charleston.

Margaret (Peg) Eastman and Edward Good
December 1, 2009

THE BARBADIANS

Carolina was presented to eight English supporters of King Charles II in 1663. The Merry Monarch was extremely generous with his grant; he gave his friends both the Carolinas and Georgia and set the western boundaries at the Pacific Ocean. Many Englishmen emigrated from the Caribbean islands to make their fortunes in the new colony.

John Lawson, an English surveyor who spent several years in the Carolinas, wrote the following when the colony was only thirty years old:

> This colony was at first planted by a genteel sort of people that were well acquainted with the trade, and had either money or parts to make good use of the advantages that offered, as most have done by raising themselves to great estates…Their inhabiting in a town has drawn to them ingenious persons of most sciences, whereby they have tutors among them that educate their youth à la mode…The merchants of Carolina are fair frank traders. The gentlemen seated in the country are very courteous, live very nobly in their houses and give very genteel entertainments to all strangers and others that come to visit them.[2]

Those first settlers pushed their trading posts as far as the Mississippi River one hundred years before Daniel Boone explored Kentucky. Indian trading was so lucrative that Henry Woodward, the first Indian agent and explorer, earned a salary equal to that of the proprietary governor. Collectively known as the Barbadians, some were probably but

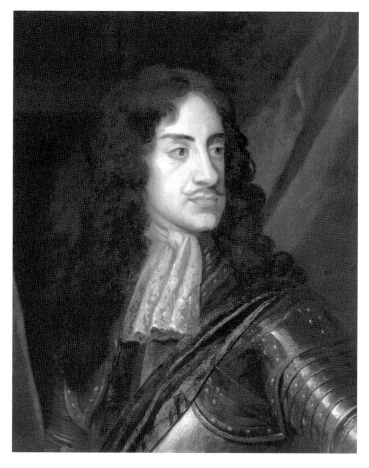

King Charles II. *Courtesy Library of Congress.*

temporarily on the islands; some had been long-established residents. As listed by historian Edward McCrady:

> *From Barbados: Proprietor Sir John Colleton; Governor James Colleton; Major Charles Colleton; Sir John Yeamans, Landgrave and Governor; Captain John Godfrey, Deputy; Christopher Portman, John Maverick, and Thomas Grey, among the first members elect of the Grand Council; Captain Gyles Hall, one of the first settlers and the owner of a lot in Old Town; Robert Daniell, Landgrave and Governor; Arthur and Edward Middleton, Benjamin and Robert Gibbes, Barnard Schinkingh, Charles Buttall, Richard Dearsley, and Alexander Skeene. Among others from*

Barbados were those of the following names: Cleland, Drayton, Elliot, Fenwicke, Foster, Fox, Gibbon, Hare, Hayden, Lake, Ladson, Moore, Strode, Thompson, Walter, and Woodward. Sayle, the first governor, was from Bermuda. From Jamaica came Amory, Parker, Parris, Pinckney, and Whaley; from Antigua, Lucas, Motte, and Percy; from St. Christopher, Rawlins and Lowndes; from the Leeward Islands: Sir Nathaniel Johnson, the Governor; and from the Bahamas: Nicholas Trott, the Chief Justice.[3]

These adventurous men helped set the stage for what has become known as the "Old South."

Thomas Pinckney (1750–1828). Charles Cotesworth Pinckney commissioned Samuel F.B. Morse, inventor of the telegraph and Morse code, to paint this portrait of his brother and one of himself. Thomas Pinckney's portrait was loaned to the Columbia Art Museum by Mrs. C.C. Pinckney. The Charles Cotesworth Pinckney painting was sold out of the family. *Courtesy Thomas Pinckney Lowndes Jr.*

Founding Mothers

The Carolina province was set up by eight Lords Proprietors following the English aristocratic model. It continued as a male-dominated oligarchy of merchants and planters once the Crown took over the colony's government. An elite few enjoyed a life of luxury that was unparalleled in other American colonies. Many wealthy planters educated their sons in England, where some studied law at the Inner Temple. These idealistic young men returned with radical ideas that changed the course of history.

And their ladies? They had no political rights and in essence belonged first to their fathers and next to their husbands. Genteel women were chaperoned before marriage and never ventured forth without the protection of father, husband, brother or another approved male escort. They were considered frail, helpless and unfit to do men's work. Yet in spite of the social restrictions of their time, women of quality wielded a lot of power. With charm, beauty and creativity, they supervised the management of their households and enforced a code of conduct that affected the very fabric of Lowcountry culture. History remembers them fondly.

Eliza Lucas

One of the most noteworthy women was born long before the War for Independence. She was a mere teenage girl when she developed a cash

crop that created one of Carolina's most lucrative exports. Fortunately for posterity, Eliza Lucas kept meticulous records—much to the delight of both historians and her numerous descendants.

Eliza Lucas was born on the Caribbean island of Antigua, where her father was posted as a lieutenant colonel in the British army. George Lucas was a "sugar baron" whose income fluctuated with the economic conditions of the times. Many of the early Antigua settlers had emigrated from Barbados and made their fortunes growing sugar cane, a crop that was converted into hard cones of white sugar, rum and molasses.

Colonial island life was harsh for the African slaves and unhealthy for their European masters. Lucas's wife suffered ill health. Hoping that a change in climate would improve her declining condition, in 1737 Lucas moved his family to the Carolina province, where he had inherited some property from his father.

It was then the custom for wealthy colonials to send their children "home" to England, where they were brought up in the care of a family friend. Eliza and her two brothers were sent to live in London with a Mrs. Boddicott. As the family papers were destroyed by fire, little is known about Mrs. Boddicott beyond correspondence left behind. What is known is that fourteen-year-old Eliza returned to Antigua shortly before the Lucas family left for the Carolina colony.

George Lucas's legacy included three plantations: Waccamaw on the Santee River beyond Georgetown; Garden Hill on the Combahee River;[1] and Wappoo, located near the junction of the Ashley River and Wappoo Creek, about four miles by land and six by water from the city. Lucas settled his family at Wappoo and mortgaged the property and the twenty slaves who worked it.

With all the trappings that wealth could buy, the Lucases soon became part of the Ashley River social circle of Bulls, Bakers, Draytons, Fenwickes, Godfreys, Linings, Middletons, Savages and Woodwards. St. Andrews Parish had one of the first roads in the province. The road ran parallel to the river, and when those early planters visited, the men sometimes rode spirited Chickasaw horses while the ladies accompanied them in chaises. Mrs. Lucas imported a four-wheel post chaise that cost seventy pounds, a vast sum in those days.

Due to the upheavals caused by the War of Austrian Secession, George Lucas's master plan did not work out. He was appointed lieutenant governor of Antigua and returned to the island in 1739, leaving his Carolina holdings under Eliza's supervision. She was only sixteen when

she assumed the domestic responsibilities of her ailing mother and the care of her little sister, Polly.

Overseeing the management of three plantations was an enormous task, for everything was produced on site: spinning, weaving and clothes, not to mention preparing meals, curing meat and preserving fruits and vegetables, tending the sick, teaching the servants their tasks and preaching morality. Young Eliza was conscientious. In her own words, she did "not eat the bread of idleness." She experimented with plants, read whatever books came her way, supervised her workers and socialized with the country gentry.

When visiting in Charles Town, she stayed with Mrs. Cleland and Mrs. Charles Pinckney, ladies who provided all the pleasures that the town afforded to genteel young ladies. Eliza also was a guest at Belmont, the Pinckney country seat, located about five miles up the Cooper River near present-day Magnolia Cemetery. These visits usually lasted from three weeks to a month at a time.

Mrs. Pinckney was the wife of a planter and lawyer, Colonel Charles Pinckney, who was later appointed chief justice. He is not to be confused with a cousin, Governor Charles Pinckney, who became known as "Constitution Charlie." Mrs. Pinckney was childless and became very fond of Eliza. Colonel Pinckney enjoyed discussing worthy subjects with the eager young teenager and lent Eliza books to enrich those conversations. When apart, Eliza maintained frequent correspondence with the Pinckney household.

The only agricultural export in the early colony was rice. When the rice market collapsed due to England's conflicts with France and Spain, Governor Lucas sought to develop another viable crop and sent his daughter various types of seeds from Antigua. Eliza experimented with ginger, cotton, alfalfa and cassava, but her most successful venture was indigo. Indigenous Carolina indigo had not been able to compete with the French product, and to maintain their lucrative monopoly, the French had outlawed the exportation of indigo seed.

Having a general idea of how to cultivate indigo from what she had observed in Antigua, Eliza spent three years growing the various strains of seeds she received from her father. The first crop was planted in March and was destroyed by frost. The second crop was planted in April and was destroyed by worms, but the third succeeded. Once her father learned that a crop had ripened, he engaged the services of Nicholas Cromwell, an overseer from the French colony of Montserrat, to teach his daughter the process of dye extraction.

The process was labor intensive. Freshly cut plants were thrown into a large wooden vat, covered with water and pounded until they fermented, a task that required about twenty hours of continuous monitoring. The thickened liquid was placed in a second vat and churned until the dye particles separated from the water. Once the mixture settled, the liquid was siphoned off. The residue was transferred to a third vat, where it sat for eight to ten hours. The paste was strained and hung in cloth bags. When the indigo hardened, it was cut into squares and left in the shade until it was hard and ready for shipping.

Fearing competition with French indigo, the nationalistic Cromwell made a mystery of the complicated process and sabotaged the dye vat by pouring too much lime water on it. Eliza had watched him carefully and reported his duplicity to her father, who immediately replaced his services with those of his brother, Patrick. Nicholas Cromwell was obliged to leave Wappoo and finish his contract on the Combahee River under the supervision of the overseer of Garden Hill.

In the meantime, both of Eliza's brothers had remained in England with Mrs. Boddicott. George received his commission when he turned sixteen. He returned to Antigua when the English and Spanish were engaged in a bitter struggle for commercial supremacy in the Caribbean and South America.

In England, young Tom Lucas had a bout with smallpox and never recovered his strength. As his health continued to deteriorate, his father decided that he should attempt the voyage home, in spite of dangers at sea and the possibility of being captured by the Spanish. Governor Lucas sent his son George to the Carolinas to bring his mother and sisters back to Antigua to greet him.

While correspondence about these family matters was in progress, Eliza's dear friend Mrs. Pinckney became increasingly ill. According to family tradition, she had been so attached to Eliza and so averse to the possibility of her leaving the colony that she had more than once declared that rather than seeing Eliza return to Antigua, she would be "willing to step down and let Eliza take her place." Mrs. Pinckney died a few months before the governor's summons came, and it did not take the widower long to propose. The sudden offer was "very agreeable" to Eliza's mama and apparently did not cause any scandal, for Governor Glen gave the marriage license. Eliza and Charles Pinckney were married in 1744.

Pleased at the highly successful union, Governor Lucas gave the couple the Wappoo indigo crop for a wedding present. The entire crop was saved

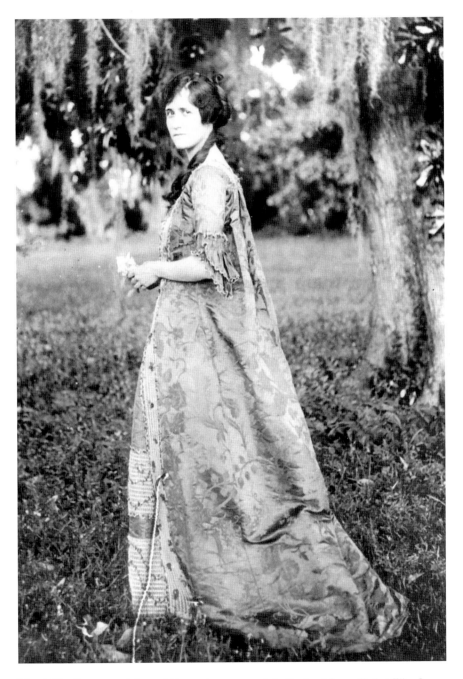

Mrs. Milby Burton models a gold brocade gown made in England from silk that Eliza Lucas Pinckney produced on her Carolina plantation. *Courtesy The Charleston Museum, Charleston, South Carolina.*

for seed. The next year, Colonel Pinckney planted part of it at Ashepoo and gave the remainder to his friends. It was not long before the local planters were competing to produce the highest-quality dye.[5]

The expanding English textile market relied on French indigo for blue dye. The Carolinians obtained an advantage over the exorbitantly priced French indigo when Parliament passed a bounty of 6*d* per pound for indigo grown in America and shipped directly to England. Carolina indigo production increased from 5,000 pounds in 1745 to more than 130,000 pounds in 1748. Indigo quickly became the second most profitable export from the province. The planters enjoyed what became known as the "indigo bonanza" and doubled their capital about every three to four years. As historian McCrady commented, "Indigo proved more really beneficial to Carolina than the mines of Mexico or Peru were to Spain."[6]

After her marriage, Eliza Pinckney had a demanding life. In addition to giving birth to four children, one of whom died young, she supervised the management of Belmont. As mistress, she made sure that wool and cotton were spun into yarn and then woven into cloth for the workers' garments.

She experimented with silk culture, something that had fallen out of fashion as it had proven too costly to produce. Eliza imported eggs, supervised the cocoon drying and maintained silk production as an occupation for the slave children, who gathered mulberry leaves and fed the silkworms. Once the cocoons were ready, she and her maids "reeled" the silk; they produced so much raw silk thread that she had the material for three dresses woven after the family moved to England in 1753. One was presented to the Princess Dowager of Wales (mother of George III), one was given to Lord Chesterfield and Eliza kept a gold brocade gown for herself.

By 1752, Colonel Pinckney had become the most prominent lawyer in the Province. He had been speaker of the House of Assembly and a member of the colony's Royal Council. When the incumbent chief justice died unexpectedly, it was only natural that Governor Glen appointed Pinckney to fill the vacancy. The appointment was not promptly confirmed by George II. This failure permitted the English ministers to appoint one of their cronies to the position instead. Unfortunately, Chief Justice Leigh was far less versed in the law than his predecessor.

Indignant that Leigh was selected, the Carolinians had Pinckney appointed commissioner of the colony. The position required that he return to London and serve as liaison between the provincial government and the Lords of

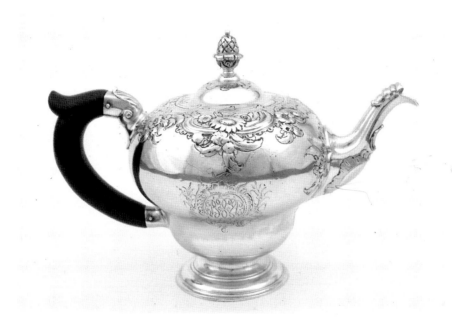

Eliza Lucas Pinckney's teapot. *Courtesy The Charleston Museum, Charleston, South Carolina.*

Trade. Pinckney had inherited a small estate in Durham, and he accepted the appointment in order to establish an English residence while his sons completed their formal education abroad.

While the Pinckneys were in England, the French and Indian War foreshadowed an interference with commerce and financial ruin for the Carolina planters. Pinckney's official position as trade commissioner made him realize that it would be prudent to dispose of his colonial properties and reinvest in a more "secure" part of the world. The Pinckneys left their sons in school and set sail for America in March 1758, taking their daughter Harriott with them. They planned to return to England as quickly as possible, and Eliza never dreamed that it would be fourteen years before she saw her precious sons again.[7]

Once back in the Carolinas, Charles Pinckney discovered that his brother had been incapacitated with paralysis and had been unable to supervise the management of his lands. While inspecting his neglected plantations, the chief justice was stricken by a fever and died shortly thereafter.

Eliza was heartbroken and never remarried. She spent the rest of her life managing her husband's plantations and invested the profits in her sons' education. They both attended Oxford and studied law in London. Both

played prominent roles in the War for Independence and were personal friends of George Washington. They both were unsuccessful Federalist vice presidential candidates. Charles Cotesworth Pinckney signed the Constitution. Thomas Pinckney was governor of South Carolina and a minister to both Spain and Great Britain.

Mrs. Pinckney suffered greatly during the Revolution. Much of her wealth, including Belmont, was destroyed or stolen, and both her sons were taken prisoner by the British.

In her last years, she lived at Hampton with her daughter, Harriott Pinckney Horry. Her last public appearance was the formal reception at Hampton when President Washington and his entourage visited on his southern tour in 1791.

The venerable matron became ill in 1793 and, accompanied by her daughter, sailed to Philadelphia for treatment. Congress was in session when she arrived, and she was visited by many of the new nation's prominent citizens. She died the following month. President Washington requested to serve as a pallbearer, a particular honor as neither of Eliza's sons was able to attend the funeral.

Almost two hundred years later, in 1989, Eliza Lucas Pinckney was inducted into the South Carolina Business Hall of Fame for her contributions to South Carolina's agriculture.

Rebecca Motte

Carolina planters were a small and close-knit society. In 1779, Eliza's son, then Major Thomas Pinckney, married Elizabeth Motte, the daughter of long-standing family friends. Chief Justice Pinckney had been taken to Jacob Motte's house in Mount Pleasant when he was stricken with malaria; he died in Motte's home. The Mottes had a plantation in Santee near Harriott Pinckney Horry's. Like the Pinckneys, the Mottes supported the colonial side.

Mrs. Motte was the daughter of Robert Brewton, a prominent member of Charles Town society. She married Jacob Motte in 1758; the couple had three daughters and lived a privileged life until the outbreak of the Revolution.

Mrs. Motte's brother was Miles Brewton, a merchant who fervently supported the colonial cause. He entertained lavishly before the hostilities began. In 1775, he was elected to the second Provincial Congress and set sail for Philadelphia. Brewton was accompanied by his wife and three

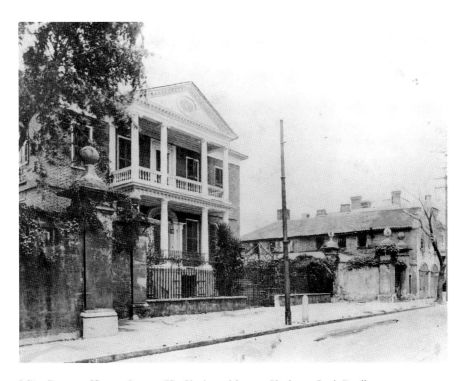

Miles Brewton House. *Courtesy The Charleston Museum, Charleston, South Carolina.*

children, whom he planned to send to England. When their ship was lost at sea, Rebecca inherited his handsome brick home on lower King Street and Mount Joseph, a plantation near Orangeburg, where she built a mansion similar to her brother's home in Charles Town.

Jacob Motte spent much of his fortune providing for the colonial army. He died in 1780, a few months before Sir Henry Clinton took Charles Town. Clinton made Miles Brewton's mansion his headquarters, as did Lord Rawdon after him. Rebecca Motte was obliged to play "hostess" to her unwanted "guests," who took over her home and forced her to move into cramped quarters. She prudently locked her three young daughters away from the British officers. Hiding in the garret, they were guarded by a "mama" who smuggled food to them. Downstairs, Mrs. Motte entertained thirty British officers at her table daily. Lord Rawdon, whose reputation with the ladies was none the best, apparently knew of the duplicity, for when he left her home, he was said to have looked up at the ceiling and remarked that he regretted he had not had the opportunity to meet the rest of her family.[8]

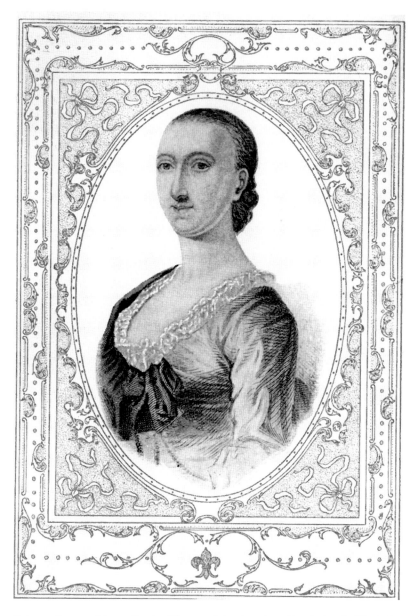

Rebecca Brewton Motte. *Courtesy* Women of the American Revolution *by Elizabeth Ellet, 1849.*

When Rawdon permitted the Motte women to leave the city, they went to Mount Joseph plantation, located where the Congaree and Wateree Rivers merge to form the Santee. Due to its strategic location, the British decided to establish a post there and make it the major convoy depot between Charles Town and the interior of the state. They evicted the Motte ladies and fortified the house. The new garrison was named Fort Motte; it was manned by British infantry under the command of Lieutenant Colonel Donald McPherson. Once again, the ladies were forced into smaller quarters and removed themselves to a small farmhouse on the hill opposite the new fort.

General Nathanael Greene had been sent to command the southern army, and he brought "Lighthorse" Harry Lee and his cavalry with him. After Greene's defeat at Hobkirk's Hill near Camden in April 1781, Colonel Lee and General Francis Marion laid siege to Fort Motte. They arrived on May 8, and Lee set up headquarters at the farmhouse occupied by the Motte women. Marion commanded the ridge of the hill about four hundred yards from where the mansion stood. The 150 British troops were outnumbered. Marion had 150 men, and Lee had 300 Regulars and 150 North Carolina Continentals.

On May 10, the Americans demanded that the British surrender the fort. McPherson refused. That evening, Marion and Lee learned that Lord Rawdon had decided to withdraw his forces from Camden and was heading toward Fort Motte. Emboldened by beacon fires announcing Rawdon's approach, on May 11 the British again refused to leave the house. Lee realized that the only way to secure the fort quickly was to burn the British out. He reluctantly informed Rebecca Motte of this necessity. She immediately agreed to the destruction, and tradition states that she produced from the top of an old wardrobe a quiver of incendiary East Indian arrows that had been given to her brother Miles Brewton years before.

By noon of May 12, the trenches dug by Marion's men were near enough to the house to enable Nathan Savage, a sharpshooter from Marion's brigade, to fire flaming arrows onto the shingle roof. (According to another account, the roof was set alight by a ball of rosin and brimstone thrown by a sling.)

The British soldiers tried to extinguish the flames, but a six-pounder fired at them whenever they appeared. In a few moments, the white flag was hung out. Marion accepted the surrender; then both sides joined in putting out the fire. Restored to her handsome home, Mrs. Motte invited the officers of both sides to dine at her table, where she is said to have received all with equal courtesy.[9]

After the war, Rebecca Motte returned to Charleston and sold her King Street house to her son-in-law, Captain William Alston of the Waccamaw Company of Marion's brigade.[10] Against the advice of her friends, she purchased valuable swamp land on credit and moved to the country. Her determination built up a successful rice plantation that enabled her to pay off her husband's debts in full. She died in 1815, leaving her children not only a valuable unencumbered estate but also a rich heritage of patriotism and honorable deportment.[11]

There was a rigid hierarchy in Carolina society: rice planters were considered the cream of the crop, followed by the sea-island cotton planters and inland cotton growers. As in England, land went to the oldest son, and the younger sons went into professions and would, hopefully, marry into ownership of a plantation. Tradesmen were at the very bottom of the social scale.

This social convention affected Eliza Lucas Pinckney's family. Her granddaughter Harriott Horry did not wish to marry any of the eligible local rice planters and eloped with Frederick Rutledge, son of Chief Justice John Rutledge, one of South Carolina's most accomplished statesmen. Rutledge had a long and distinguished career and enjoyed the friendship of many of the founding fathers. During the Revolution, Rutledge worked for the southern Continental army. As president of South Carolina, he was able to restore order to the state while in office. He held numerous elective offices and served as a delegate to the First and Second Continental Congresses and the Constitutional Convention. He served as chief justice of the United States Supreme Court and the South Carolina Supreme Court.

The chief justice was also known for his fine wine cellar and was proud of his ability to drink two quarts of Madeira a day. Toward the end of his life, Rutledge was deeply in debt and threatened with the loss of his entire fortune. Stricken with gout, overwhelmed with the enormity of his debt and mourning his wife's sudden death, he spiraled into a deep depression. He attempted suicide.[12] It was kept as quiet as possible, and nobody in the Pinckney-Horry family ever dreamed that tragic predisposition would affect them many years later.

The seventh child of Harriott Horry and Frederick Rutledge was John Henry Rutledge, grandson of the chief justice. His sensitive nature and loving ways made him the darling of the family. He hunted the land and charmed his mother and grandmother with his escapades. He was an accommodating child who never caused a bit of trouble—that is, until he fell in love with a pharmacist's daughter.

It was understood at Hampton that planter families were to marry within their own social class. The matriarchs could not convince John Henry that he must relinquish his affections, nor would the girl's father permit his daughter to marry into a proud family that would consider the bride even less desirable than one of their own enslaved black servants.

Thwarted on every side, John Henry took to a rocking chair in his upstairs room, and a deep depression settled in. He rocked and he rocked and he rocked. One day, a shotgun blast startled the occupants of the house. John Henry's mother and grandmother dashed upstairs only to see life seep out of his bleeding body. Unable to bury a victim of suicide in the family plot, John Henry's body was interred by the stairs of the river side of the mansion. It is said that the chair continued to rock until the day it was removed from the house, and family servants claimed that the blood that dripped from his bleeding body bubbled back every time it was scrubbed off the floorboards.[13] The story of his ghost lingers to this day.

Sons of Liberty

54 King Street

In 1763, England's prime minister, George Grenville, set about balancing the king's budget to offset the massive national debt incurred by the Seven Years' War (known in America as the French and Indian War). This was done by a series of taxes that affected the people in both Britain and the colonies.

The American Duties Act of 1764 placed a 3*d* tax on imported molasses and established the machinery to enforce the legislation. Molasses was used in the manufacture of rum and primarily affected New England distillers, who avoided the tax by smuggling or bribing customs officials. Later that same year, Parliament passed the Currency Act, which prohibited the colonies from printing paper money. Imports from Britain far exceeded colonial exports, and without sufficient specie in circulation, the act forced colonials to buy on credit from British merchants. The financial crisis after the Seven Years' War forced merchants to call in their debts, thus creating hardships and bankruptcies for colonial importers.

It was the Stamp Act of 1765, however, that caused a crescendo of colonial opposition. The act was intended to defray the costs for stationing troops in North America during the French and Indian War. It required that all legal documents, newspapers and playing cards have a stamp affixed on them or that they be printed on stamped paper.

It was Parliament's first serious attempt to assert governmental authority over the colonies. The act was met with great resistance. Colonials viewed it as a violation of the right of Englishmen to be taxed *only* with their consent.

The rallying cry became "taxation without representation." By the end of 1765, all colonial assemblies except Georgia and North Carolina had sent formal protests to England.

Organized groups calling themselves the Sons of Liberty began to coalesce throughout the colonies. Their leaders were from the middle and upper echelons of society; they relied on public demonstrations to expand their power base. People were fed up with the arrogant, wealthy representatives of the Crown. Popular demonstrations occurred all along the eastern seaboard.

In Boston, an angry mob hanged an effigy of the Massachusetts stamp distributor. Later, it was cut down and paraded through the streets in a mock funeral procession that culminated in burning the stamp distributor's home, stable house and coach and chaise. Not content, twelve days later the populace attacked and pillaged the lieutenant governor's house and emptied his wine cellar. Demonstrations spread to other colonies.

The resistance to British rule united the colonies. In October 1765, they convened the Stamp Act Congress in New York. Christopher Gadsden of South Carolina was a key player. While he was searching for legislative redress in New York, the Liberty Boys were agitating in Charles Town.

For safety and anonymity, the origins of Charles Town's Sons of Liberty have been obscured. Collectively known as "mechanics," they were drawn from a small middle class of talented, prosperous artisans who composed about 20 percent of the city's population. Mechanics represented all the trades, and among them were shipwrights, coopers, candle makers, tanners, tailors, silversmiths, coach makers, printers, engravers and gunsmiths. Some maintained shops and others worked independently.

Even before the Stamp Act crisis, the mechanics had united for political and benevolent purposes. Although they paid taxes and had the right to vote, they did not have the wealth and influence to be elected to the assembly. The writings of Christopher Gadsden, as printed in Peter Timothy's *Gazette*, seemed to express their sentiments, and they adopted Gadsden as their spokesman. They met under a live oak tree in Isaac Mazyck's pasture in Hampstead on Charleston Neck (Alexander Street just north of present-day Calhoun Street).

When the Stamp Act was repealed, twenty-six men gathered in Mazyck's pasture for a collation prepared for the occasion. Christopher Gadsden addressed the group. According to one attendee, Gadsden warned that they should be prepared for a struggle to "break the fetters whenever again imposed on them." Afterward, the men joined hands around the tree and

called themselves "defenders and supporters of American Liberty." The gathering place was thereafter known as the "Liberty Tree."

The Liberty Tree was used for meetings during the ensuing years, and in August 1776, thousands gathered there to hear Major Barnard Elliott read the Declaration of Independence. When Charles Town surrendered to the British in May 1780, General Clinton ordered that the Liberty Tree be chopped down.

Britain continued to pass laws that affected colonial commerce, and resistance heightened. The Tea Act of 1773 caused another crisis. It enabled the financially beleaguered East India Company to sell tea to a few favored agents in each colony. In September and October 1773, seven ships carrying East India Company tea set sail for the colonies: four to Boston and one each to New York, Philadelphia and Charles Town.

Once again, the Sons of Liberty began a campaign to force consignees to resign, as had occurred during the Stamp Act crisis. When three of the four ships destined for Boston arrived in the harbor, a group of men, some thinly disguised as Mohawk Indians, boarded the docked vessels and dumped 342 chests of tea into the water.

In December 1773, the *London*, under the command of "gentleman" Captain Alexander Curling, arrived in Charles Town with 257 chests of tea consigned to agents of the East India Company. Radicals hastily called a meeting to prevent the tea from being unloaded. They adopted a resolution "not to import, either directly or indirectly, any teas that will pay the present duty laid by an act of the British Parliament for the purpose of raising revenue in America."[14]

The consignees agreed under duress not to receive the tea. Although the profit-minded merchants were reluctant to boycott imported tea, the radicals anonymously threatened to burn the *London* and the wharf where it was moored. Because no one appeared to pay the duty on the cargo within the legal time limit, Crown officials seized the tea and stored it in the Exchange without incident.[15]

Several other tea ships arrived in Charles Town. In July 1774, a cargo of tea arrived, and the captain promised that he would not land it. He took it ashore anyway and placed it in the Exchange. Local citizens were enraged. One hundred angry radicals boarded his docked vessel on one side as the captain hastily escaped off the other. To prevent the vessel from being burned, it was removed to the outer parts of the harbor.

On November 3, Charles Town finally had its own "tea party." Under the supervision of a Committee of Observation, the consignees—Messrs

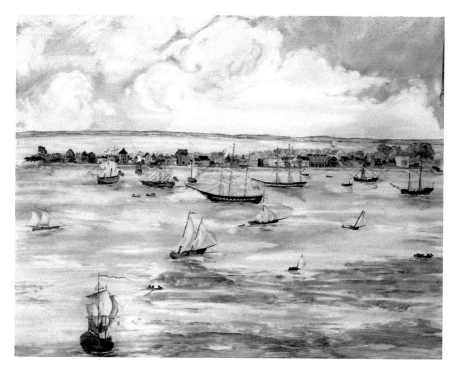

Charleston Harbor, taken from a dining room mural painted by Lynne Riding. *Courtesy the Thompson family.*

Lindsay, Kinsley and Mackenzie—were forced to board a ship bearing tea and dump their precious cargo overboard in an "oblation to Neptune." A crowd ashore gave three hearty cheers after the emptying of each chest.[16]

One of the most active Sons of Liberty was a "housewright" named James Brown. He was involved in some major local building projects and was a well-known personage in town. Brown served on the Committee of Ninety-nine (fifteen merchants, fifteen mechanics and sixty-nine planters), which coordinated the nonimportation of British goods into South Carolina.

When the royal government evacuated Charles Town in 1775, Brown was hired to repair Fort Johnson, located at the tip of James Island. He represented St. Philip's and St. Michael's Parishes in the First and Second Provincial Congresses. He also served in the First and Second General Assemblies.

Brown took part in the defense of Charles Town and was captured by the British when the city fell. Charged with promoting and fomenting the "Spirit of Rebellion," he accompanied Christopher Gadsden and other leading "rebels" to exile in St. Augustine, Florida. These men fared far better than

those incarcerated aboard prison ships in Charles Town. Although closely watched, they were allowed to take servants, rent their own quarters and buy their own food. Brown was not exchanged and remained in St. Augustine until the war ended.

Following the Revolution, Brown returned to Charleston. His construction business took him to Fairfield County, where he contracted to build a courthouse in Winnsboro. Due to the upheavals after the Revolution, he found it difficult to get paid. He was awarded the contract to build the first State House in Columbia. When construction ran behind schedule, Brown ran into contractual difficulties and again had trouble getting paid. Brown was still living in Charleston when he died in 1790.

In 1768, Brown built a sturdy, three-story, wooden town house and dependencies at 50 King Street. (The number was changed to 54 King after the 1886 earthquake.) It was a typical single house with two rooms separated by a central stair hall. Brown sold the property nine years later and moved to Camden. The house changed hands numerous times before it was purchased by George A. Trenholm in 1863.

Trenholm was a wealthy merchant and partner in John Fraser & Company of Charleston and Fraser, Trenholm & Company of Liverpool. Although he served as secretary of the treasury for the Confederate States of America for eight months, during the war, his primary occupation was blockade running. Trenholm never lived at 54 King Street; his residence was the Patrick Duncan mansion located at 172 Rutledge Avenue, a house that is now the flagship building of Ashley Hall School. Some think that Margaret Mitchell used Trenholm as the prototype for Rhett Butler in *Gone with the Wind*.

While the money was flowing in, Trenholm and his partners purchased a great deal of investment property in Charleston and elsewhere. When the war ended, the Federal government sought to recover duties on goods imported during the hostilities. It filed suit against John Fraser & Company as an agent of the Confederacy. Although much of the company's real estate was seized and sold, 54 King Street was among properties that were put into a trust for division among the partners. James T. Welsman, one of the partners, was allocated 54 King Street and given title in 1868. Welsman became a commission merchant on Vanderhorst Wharf and lived at the corner of Church and South Battery. Upon his death, 54 King Street was conveyed to Fritz Jordan.

Jordan lived in the house and operated a grocery store and saloon at 58 King. He died of apoplexy, and his wife lived in the property until her death in 1917.

Rear view of 54 King Street before a three-story addition was built between the dependency and the main house. *Courtesy the Thompson family.*

The property passed through a series of owners in the twentieth century. Of note were the Frederick Rutledge Bakers, who afterward purchased and renovated both 21 King Street and 13 East Battery. Baker was married to Hazel Middleton and worked as superintendent of Middleton Compress and Warehouse Company; he subsequently moved to Sumter as a representative of Middleton & Company. The Bakers sold 54 King Street to Susan Rutledge Moore, wife of B. Allston Moore, a Charleston attorney. Moore was a lecturer on legal medicine at the Medical College of South Carolina and a principal in Buist, Moore, Smythe and McGee, one of Charleston's most prestigious law firms. After the Moores died, the property was sold to Anne C. Burris, wife of Alonzo "Lonnie" Burris, president of Burris Chemical Company.

The Burrises subdivided the property and conveyed the portion currently known as 54 King Street to Dr. W. Leigh Thompson and Maurice H. Thompson in January 1995.[17] The late Dr. Thompson is recognized for significant contributions to medical care and education, drug development and public health. His pioneering initiatives in critical care, pharmaceutical development innovations, information technology management and collaborations with regulators have had a sustaining positive impact on the industry, patients and the many professionals whom he mentored. His wife

pursues historical preservation and research. They coauthored *Murder at Spoleto* and an e-book about bioterrorism.

The Thompsons made extensive additions to 54 King Street, including a two-story library over a garage built between the rear of the main house and the brick dependency. During construction, they discovered a cannonball hole in the third-floor walls. They re-landscaped the yard using original eighteenth-century brick. With the precision of a scientist, Leigh meticulously designed the eighteenth-century maze that was placed around the front garden fountain.

THE DUELLO

2 St. Michael's Alley

The art of mortal combat is as old as history itself. All great nations have had a warrior class that enabled them to conquer their neighbors and plunder their lands. From the ancient Spartans to medieval combatants, legend has romanticized heroic stands of brave men who pitted their skills against their foes. Weaponry has changed, but the instincts have remained.

In the early seventeenth century, King James I of England made a proclamation against the practice of dueling, and these sentiments were echoed by many others in the ensuing years.

The late eighteenth-century physician/historian David Ramsay wrote that mistaken views of honor caused duels, further stating that they occurred more often in Carolina than all the nine states north of Maryland, something he attributed to summer temperatures. Reasons for duels were infinite: rivalries, a slight, a dispute about a dog, a pinch of snuff, a servant, a goose. Rarely were they about women. The main cause of duels in South Carolina was politics.

Ordinarily, duels were fought in secluded places. The most popular Charleston location was the Washington Race Course on Meeting Street Road a little above the old ropewalk, near the center of which stood Creighton's tavern. After dueling was banned in South Carolina, combatants went across the state line to isolated spots in Georgia. Others upheld their honor by fighting on military lands, where the participants were free from arrest. Charlestonians disliked publicity, and relatively few duels received public notice before the nineteenth century.

The death of Alexander Hamilton in 1804 led to a national outcry against dueling. It took eight more years before the South Carolina legislature prohibited the custom. Conviction carried a $2,000 fine, imprisonment for twelve months and disqualification from holding any position of trust. Instead of quelling the practice, this law seemed to increase the need to preserve one's honor.

Each combatant had a "second" who acted on his behalf, first to prevent the bloodshed, if possible; second to see that the duel was fought according to predetermined rules; and third to assist if his principal was shot or killed in the confrontation. It was a gentleman's sport and, as such, had a rigid code of honor.

Not all duels fit into the prescribed rules. In 1771, Peter DeLancy, deputy postmaster general, arranged for a private late evening confrontation with Dr. John Haley at Holliday's Tavern. Haley was a well-respected Charleston physician. DeLancy was the brother of Mrs. Ralph Izard. On that fateful evening, a room was hired, the door was shut and shots were fired. DeLancy was killed, but nobody had witnessed the shooting. The trial afterward became a sensational dispute between the local Whigs and the Tories. Haley was represented by James Parsons, Charles Cotesworth Pinckney, Thomas Heyward and Alexander Harvey.

Tragically, families were wrecked when lives suddenly ended prematurely. Some young contenders had not yet obtained their majority (age twenty-one) when they met their sad fate. Some were not so foolish. The *City Gazette* published the following on January 9, 1792:

I have two objections to this duel matter. The one is, lest I should hurt you, and the other is, lest you should hurt me. I do not see any good it would do me to put a bullet through any part of your body. I could make no use of you when dead for any culinary purposes, as I would a rabbit or a turkey. I am no cannibal to feed upon the flesh of men. Why then shoot down a human creature of which I could make no use: a buffaloe would be better meat. For though your flesh might be delicate and tender, yet it wants that firmness and consistency which takes and retains salt. At any rate, it would not be fit for long sea voyages. You might make a good barbeque, it is true, being of the nature of a raccoon, or an opossum, but people are not in the habit of barbecuing anything human now. As to your hide, it is not worth the taking off, being little better than that of a year old colt.

As to myself, I do not much like to stand in the way of anything that is harmful. I am under apprehension that you might hit me. That being the

case, I think it most advisable to stay at a distance. If you want to try your pistols, take some object, a tree or a barn door, about my dimensions, if you hit that, send me word, and I shall acknowledge that if I had been in the same place, you might also have hit me. Signed Captain Farrago

Another tongue-in-cheek response was made by an apothecary who refused to give his seat to an officer's lady at a theatrical performance. Feeling insulted, the officer sent him a challenge. The apothecary was punctual but, having been unaccustomed to firing a pistol, proposed another way to settle the dispute. He drew a pill box from his pocket, took out two pills and addressed his antagonist: "As a man of honor, Sir, you certainly would not wish to fight on unequal terms. Here are two pills, one composed of the most deadly poison, the other perfectly harmless. We are therefore on equal ground if we each swallow one. You shall take your choice, and I promise faithfully to take that which you leave." The affair was settled with a laugh.

There was even a recorded instance of slaves engaging in a duel. Two butlers fought over a yellow-skinned girl. Acting as seconds, their owners loaded muskets only with powder and no ball. After the shots were fired, each antagonist dropped, and the animosities were considered settled.

In 1838, John Lyde Wilson published what was considered the highest authority of the duello in the United States, *The Code of Honor or Rules for the Government of Principals and Seconds in Dueling*. The preface states that the code was written to save human life. Wilson was a prominent attorney who lived in Georgetown, the second most important town in South Carolina. In 1809, he married Charlotte Alston, the sister of Governor Joseph Alston (husband of Theodosia Burr). After his first wife died, her sister Lady Nesbit took Wilson's two motherless daughters to England. In 1825, Wilson married Rebecca Eden, a ward of Aaron Burr. She is said to have squandered nearly all of her large inheritance. By this marriage were two daughters and a son who died at the age of fourteen.

Wilson served in both the South Carolina House of Representatives and in the State Senate, where he was made president in 1822. That same year, he was elected governor. During his administration, the Court of Appeals was established as a separate court. Wilson supported states' rights, advocated the humane reform of Negro laws and backed the incorporation of the Medical College of South Carolina in 1823.

According to tradition, Wilson was also a bully. One evening at a St. Cecilia Ball in Charleston, he wanted to dance with a belle who was "sitting

out" a dance with a young man who was a cripple. Wilson stepped on his rival's toes, but his victim chose to ignore the offense and smiled at him. Later that same evening, Wilson tried the same trick on Henry A. Middleton, a prosperous Georgetown planter and a much more formidable foe. Harsh language and a challenge followed. The parties could not settle on the terms, and a series of pamphlets and public notices were circulated to justify each antagonist's position.

The animosity did not stop at published insults. Middleton despised Wilson for his refusal to fight and tried in every way to embarrass him. In 1826, when they were both candidates for the Senate from Prince George Winyah, Middleton published a letter disparaging Wilson's character when he closed his accounts as governor. The matter was resolved, and Wilson defeated his rival.

According to the late Samuel G. Stoney, a professor at the College of Charleston, Wilson was made the circuit court judge in 1827. Middleton traveled with Wilson and the attorneys as they made their rounds to the various towns. Middleton always requested a seat opposite Wilson when the group dined in the evening and glared at him across the table. The constant scrutiny was so unnerving that Wilson finally resigned his judgeship.

Wilson served as a Charleston delegate to the Nullification Convention. The Order of Nullification declared the tariffs of 1828 and 1832 null and void and threatened that if the government tried to enforce them, South Carolina would set up its own government. President Andrew Jackson issued a proclamation to denounce this action.

In 1834, as captain of the Eutaw Heavy Artillery, Wilson published a book on field artillery for the South Carolina militia. An enthusiastic patron of the turf, he was a leading member of the South Carolina Jockey Club. In 1840, he published "Rules for Betting," a synopsis of valuable information for the sporting man.

Wilson was a classical scholar, wrote poetry and translated the "Golden Ass of Apuleius." He was considered a graceful public speaker. He was also a crack shot with a high temper. His ideals of chivalry caused him to be involved in numerous "affaires d'honneur," where his cool head and keen marksmanship invariably made him the victor.

After Wilson retired from public life, he lived at 2 St. Michael's Alley above his law office. He died in almost utter destitution in 1849. The former governor was given full military honors due the high station he had once occupied and was buried next to his second wife in the cemetery of St. Paul's Church.[18]

Joel R. Poinsett, the congressman and diplomat for whom the poinsettia is named, owned 2 St. Michael's Alley at one time. After the Revolution, many Charlestonians built houses farther up the peninsula, and uptown became another highly desirable residential area. During Reconstruction, many downtown houses became segregated tenements occupied by whole families crowded into a single room. By the early twentieth century, local residents regarded both St. Michael's Alley and Elliott Street as slums where uncivilized tenants tossed their refuse out of windows onto the street below. Catfish Row, depicted in *Porgy and Bess*, was just around the corner on Church Street.

Thanks to preservation efforts, the area was gradually restored. The late Miss Mary Stuart, who helped found Charleston Day School, was a tenant at 2 St. Michael's Alley. Built by Isaac Holmes as a tenement, the building had experienced many changes since the 1740s, and Miss Stuart's tenancy was no ordinary occupancy. She often heard steps pacing above her on the third floor; then a gate latch lifted and steps were heard descending the stairs. Another tenant also heard steps and sounds like someone dragging a chain. Apparently the "ghost" did not like entertainments, for an Episcopal priest who lived there in the 1970s heard loud noises overhead every time he gave a party. Shortly after they moved in, the current owners were suddenly awakened at 2:00 a.m. by

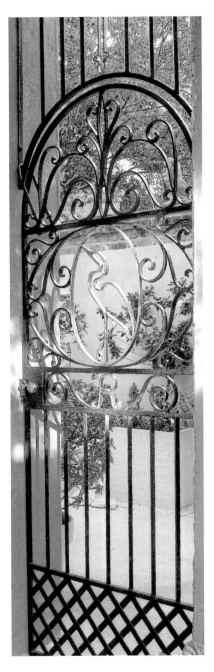

A Philip Simmons gate. *Photograph by Richard Donohoe.*

the sound of footsteps coming down from the third floor. The footsteps stopped once the third floor was extensively renovated. In all, at least five independent twentieth-century residents experienced strange sounds on the third floor of Number 2.

Quite naturally, everyone guessed the identity of the "ghost." Some talk about a duel fought in St. Michael's Alley. It is said that the lawyer who lived at Number 2 fell in love with an actress in a French traveling troupe that was playing at the Dock Street Theatre. Her jealous lover shot the attorney in the groin. Wounded, he went back inside and died on the third floor.

The current owner is a respected Episcopal minister. He did not have the house exorcised, but he did engage the celebrated blacksmith Philip Simmons to craft a wrought-iron gate to his courtyard. It is highly symbolic, for below a golden Celtic cross is a South Carolina egret and the discrete initial of the owner's last name.

There are two historical markers on St. Michael's Alley. Nothing commemorates the controversial Governor Wilson's residency at Number 2.

Politics and Pride

First Recorded Lowcountry Duel

Although the early English attempts to colonize the Carolina grant had been unsuccessful, Anthony Ashley Cooper, the first Earl of Shaftesbury, persuaded the other Proprietors to fund another expedition in 1669.

John Locke prepared a constitution for governing the new colony. In it, the Proprietors delegated authority to their representatives and retained veto power. The ruling Grand Council consisted of a governor and proprietary representatives, an upper house of ten colonials selected by the leading landowners and a Commons House of Assembly composed of twenty members selected by landed "freedmen." Power of the Commons House was limited to discussion of proposals from the other two parts of the Grand Council. The constitution set up the division of the land, protected slavery and granted religious freedoms to non-Catholic settlers.[19]

The earliest arrivals were given an opportunity to become titled landholders. All they needed was enough money to purchase the land. Depending on one's pocketbook, one might become a baron, cassique or landgrave. A thriving aristocracy was soon established, for land could be grabbed up for a penny an acre.

Many of the earliest settlers were from Barbados, and they were joined by Englishmen from other Caribbean islands. These men settled mainly on the Cooper River and quickly dominated the new colony. Bringing with them knowledge of agriculture, exploration and the Church of England, they built an agrarian aristocracy based on forced labor of African slaves and, at times, captive native Indians.

From the very beginning, the Caribbean transplants opposed the Proprietors and their Fundamental Constitution. Generally known as the "Goose Creek Men," they were politically united by a common interest in preserving the enormous profits made through the native Indian slave trade and by trafficking with pirates. It was not long before they gained control of the Commons House of Assembly. The Proprietors soon learned to be wary of the Goose Creek Men and their self-serving intrigues. The ratification of the Fundamental Constitution was a major source of acrimony among the two factions, especially when the Commons House was in session.

In 1673, the colony's guiding force, Anthony Ashley Cooper, fell from grace and was imprisoned in the Tower of London on more than one occasion. In 1681, he was exiled to Amsterdam, where he died in 1683. Sir William Craven replaced Shaftesbury as proprietary leader in 1681.

Events in England greatly influenced the fledgling colony. James II succeeded his brother to the throne in 1685. His autocratic policies and Roman Catholicism caused him to be deposed in the Glorious Revolution of 1688. Instead of choosing James II's Catholic son, Parliament invited his Protestant daughter Mary and her husband, William of Orange, to co-reign.

It was during the turmoil in England that Craven determined to put an end to the factionalism of the Goose Creek Men. He theorized that he could defeat their purposes by increasing the non-Anglican majority who already outnumbered the Church of England settlers from the Caribbean. He removed the Goose Creek Men from office and denied them access to the lucrative Indian slave trade. Craven appointed James Colleton, the son of one of the original Proprietors, governor. He was instructed to investigate the relations between the colony's leaders and the pirates who were wreaking havoc in the Caribbean.

Shortly after Governor Colleton's arrival, the Spanish raided the Scottish settlement at Stewart Town. The colonists wanted revenge, and Colleton declared martial law to stop an ill-advised retaliatory expedition to Spanish Florida. This kept the Goose Creekers at bay for a time.

Colleton was no match for his wily antagonists, however, and soon found himself in serious trouble. The Goose Creek Men gained his confidence and suggested that he deserved to increase his salary through instituting an excise tax on imported liquors. Colleton took the bait. His adversaries promptly voted against the act and accused the governor of trying to enslave and ruin the people. The ensuing hullabaloo forced Colleton to dissolve the 1689 Parliament. Luckily for Colleton, England was at war with France, and

Colleton again placed the colony under martial law. Until threats posed by the French disappeared, the Goose Creek Men were silenced.

John Stewart supported the proprietary government and had championed Governor Colleton. As a reward for faithful services, Stewart had been placed in charge of Wadboo Barony, Colleton's land grant, located at the head of the Cooper River. Stewart received several grants of land in appreciation for his experiments in silk production. He was an Indian trader and an expansionist who had a high opinion of himself.

Then Seth Southell arrived from North Carolina and claimed that, as resident Proprietor, he had the right to be governor. The Goose Creek Men used this as a pretext to remove Colleton in 1690. He was barred from holding office and was banished from the colony. Colleton died in Barbados in 1707.

The Goose Creek Men continued their attempts to gain control of the colony through numerous constitutional debates in the Commons Assembly. Their champion was Captain Job Howe of Howe Hall. Howe had settled in St. James Goose Creek Parish and owned several plantations. He had quickly become embroiled in local politics and was extremely critical of the proprietary regime. He held the offices of surveyor and surveyor general. It was Howe who had accused Governor Colleton of disloyalty to the king in the provincial parliament in 1690. He apparently had great oratory talents.

One evening when the legislature was in session, the legislators went out on the town. There were angry words, and Howe vowed to "thresh" Stewart in front of the governor. This precipitated the earliest known duel in the Carolinas. The confrontation had all the elements of a seventeenth-century theatrical farce. Early the next morning, the two men and their seconds met in the woods. The antagonists drew their swords and faced each other, waiting to exchange lunges. Neither moved! They stood still for a full six minutes. Stewart claimed afterward that Howe, being the aggressor, should have struck first.

During the interminable standoff, two constables sent by the governor arrived to stop the bloodshed. Stewart's second grabbed his arm, whereupon Howe struck Stewart with a hickory stick and ran off. In a letter to William Dunlop in Scotland, Stewart claimed that he jerked his arm free, drew his "scymetar" and chased his assailant, swinging his sword within an inch of Howe's retreating neck.

Stewart wrote that he had sent Howe word that he "was a better Trimmer of Politicks than a swordsman and bid him tell him that…he was a cowardly roage and a great lyar." He claimed that Howe became the laughingstock

of the town. Stewart complained that he was forced to sleep in his bed with both a naked sword and a charged gun as protection from the local citizenry who were not overly fond of him or his "scymetar."[20]

Job Howe's colleagues did not share Stewart's opinion of him, for he was twice reelected Speaker of the Commons House of Assembly, serving three consecutive terms (1700 to 1705). In 1700, Speaker Howe supported an act for a provincial library and was named a commissioner and a trustee. Howe died in 1706 during the yellow fever epidemic.[21]

The Goose Creek Men succeeded in ending proprietary control in 1719 when Carolina became a Crown colony.

Yankee Doodle Duel

There have been many duels in America, but with the exception of Aaron Burr's sensational shooting of Alexander Hamilton, few have received the instant notoriety of that between two Continental generals in Charles Town when Job Howe's descendant, General Robert Howe, challenged Charles Town's feisty general, Christopher Gadsden.

Gadsden had impressive credentials. Although he had organized the first artillery corps in South Carolina in 1756 and had taken part in the Cherokee expedition in 1761, his fits of temper rendered him unsuitable for military life. He returned to the private sector, where he became a highly successful merchant, amassing four stores, several merchant vessels, one of the largest wharfs in North America, two rice plantations and a residential district called Gadsdenbro in Charles Town.

Gadsden served in the Commons House of Assembly for three decades. He defied the British whenever possible, and they finally denied his seat on a minor infraction. This caused him to oppose the British even more vehemently. He opposed the Stamp Act and occupied a seat in the First Continental Congress. Gadsden served in the Continental army, rising to the rank of brigadier general. He designed the yellow flag with a coiled rattlesnake poised over the words "Don't Tread on Me." After the British captured Charles Town, Gadsden was among the twenty-nine exiles sent to St. Augustine in August 1780. Unlike the other political prisoners, he was imprisoned in the Castillio de San Marcos for ten months because he refused to swear a second parole. Gadsden was active in civic affairs after the war ended and voted for ratification of the U.S. Constitution.[22]

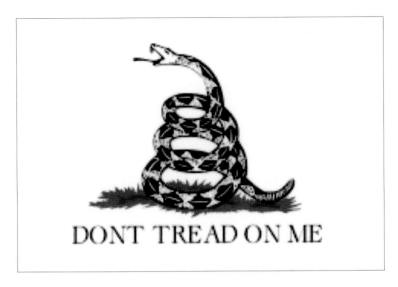

The flag designed by Christopher Gadsden.

The origin of the conflict was because Gadsden resented North Carolina's Howe being given command of the South Carolina troops after General Moore left Charles Town.

Robert Howe had served in the North Carolina militia before the Revolution. Once hostilities with the British commenced, Howe served under the command of General Charles Lee and quickly rose to the rank of major general. In 1776, he was given command of the Southern Department of the Continental army.

When he led an expedition to capture St. Augustine, Florida, in the spring of 1777, Howe left General William Moultrie in charge. After Moultrie joined him, Gadsden was the highest ranking officer in South Carolina and assumed command. Howe's Florida mission failed because of inadequate supplies, insubordination and a fever epidemic; the depleted Continental army returned to Savannah. By the time Howe came back, he had lost the confidence of many generals. Gadsden was particularly leery of relinquishing his command to a general whose judgment he no longer trusted.

Within six months of Howe's return, Gadsden wrote the general demanding to know by what right he commanded the South Carolina troops. General Howe responded appropriately and thought the matter was settled. Gadsden, however, did not. He wrote to William Henry Drayton, a member of the South Carolina General Assembly, questioning Howe's command

in South Carolina and resigned his commission in protest. Gadsden was mortified when his resignation was accepted along with that of several other generals and the House of Assembly ratified Howe's appointment.

When Drayton was elected to the Continental Congress, Gadsden again took up the issue. He wrote Drayton explaining that his resignation was different and that he was not questioning the authority of the Continental Congress, but rather that he resigned because the South Carolina Assembly would not enquire as to whether Congress had given Howe the command. Drayton provided him a copy of the letter Howe had written to the Continental Congress the previous year. On July 4, Gadsden proceeded to annotate Howe's letter with a long diatribe against not only the hapless Howe but also Henry Laurens. Drayton wisely decided not to circulate the epistle in Philadelphia.

In Charles Town, Gadsden spread his correspondence far and wide. The ongoing feud between the two generals was a welcome diversion to those enduring the summer heat and the boredom of military inactivity. Howe responded to Gadsden's slanders by demanding a public apology or satisfaction on the field of honor. Gadsden accepted his challenge, and efforts of friends failed to convince either antagonist that such a confrontation was unnecessary.

The duel was originally scheduled to take place under the Liberty Tree. When the combatants arrived, they discovered that a large crowd had come to witness the spectacle. Some had even climbed the tree to get a better view. The combatants decided to go to a more private location just north of the city. Gadsden and his second, Colonel Barnard Elliott, proceeded in a carriage while Howe and Charles Cotesworth Pinckney followed on horseback. Reports vary as to exactly where the shots were fired, but according to tradition, the duel took place on the property of the Reverend William Percy near what is now the intersection of Rutledge Avenue and Bogard Street.[23]

Once on the field, Gadsden insisted that General Howe fire first. Howe's bullet grazed Gadsden's ear, whereupon Gadsden took his time and deliberately fired into some nearby trees, much to everyone's relief. Honor satisfied, Gadsden apologized, and the two generals shook hands and parted.

Afterward, Gadsden wrote Henry Drayton that the affair was a private matter and complained that the duel had appeared in newspapers just four days after it occurred. To the chagrin of the colonials and delight of the British in New York City, Major André, the famous British spy, quickly

penned a poem, "On the Affair between the Rebel Generals Howe and Gadsden," to be sung to the tune of "Yankee Doodle."[24]

In November 1778, Howe went back to Savannah and took command, over the objections of the Georgians. His attempts to defend the city failed after a surprise night attack by the enemy. Howe was later court-martialed and honorably acquitted. His notorious womanizing caused him to be described by a "Lady of Quality" as "a horrid animal, a sort of woman-eater that devours everything that comes his way." In time, the Continental Congress delegates from both South Carolina and Georgia demanded his recall from the South because of an escapade with a woman.[25] He was transferred north to General Washington's staff, where he was a member of the military tribunal that sentenced Major André to be hanged in 1780.

André was reputed to have been a great favorite in society during the British occupation of both Philadelphia and New York. He was well educated and sought after in the drawing rooms because of his considerable social graces. He was able to draw, paint, write verses effortlessly, cut silhouettes, play the flute and charm the ladies. André was with Sir Henry Clinton during the amphibious assault on Charles Town in 1779. He met his downfall when he was placed in the British Secret Intelligence and was caught conspiring with Benedict Arnold about surrendering the fort at West Point. He was tried as a spy and condemned to be hanged. His demeanor throughout his ordeal earned him such respect that George Washington sent him breakfast from his table each morning. André sketched a self-portrait on the eve of his execution and wrote a poem that was found in his pocket after his death. He went to the gallows in full uniform, put on his own blindfold and placed the noose around his own neck. He met his fate with such heroic dignity that a witness reported that there was not a dry eye among the spectators. The account of the last day of Major André can be found in *The American Revolution: From the Commencement to the Disbanding of the American Army Given in the Form of a Daily Journal, with the Exact Dates of all the Important Events; Also, a Biographical Sketch of the Most Prominent Generals* by James Thacher, a surgeon in the Continental army.

Major Andre's Parody
Charleston, S.C. September 1st

We are favored with the following authentic account of the affair of
honor, which happened on the 13th of August 1778. Eleven o'clock was
the hour appointed for Generals H. and G. to meet, accordingly, about
ten minutes before eleven, but hold, it is too good a story to be told in
simple prose.

To the tune of "Yankee Doodle"

It was on Mr. Percy's land
At Squire Rugeley's corner
Great H. and G. met, sword in hand
Upon a point of honor.

G. went before, with Colonel E.
 (Bernard Elliott)
Together in a carriage
On horseback, followed H. and P.
 (Gen. C.C. Pinckney)
As if to steal a marriage.

On chosen ground they now alight,
For battle duly harnessed
A shady place and out of sight,
It showed they were in earnest.

They met, and in the usual way,
With hat in hand saluted,
Which was, no doubt, to show
 how they,
Like gentlemen disputed.

And then both together made,
This honest declaration,
That they came there by honor
 led,
And not by inclination.

That is, they fought, 'twas not
 because
Of rancor, spite or passion,
But only to obey the laws
Of custom and the fashion.

The pistols, then before their eyes,
Were fairly primed and loaded;
H. wished, and so did G. likewise,
The custom was exploded.

But, as they now had gone so far
In such a bloody business
For action straight they both
 prepared,
With mutual forgiveness.

56

But lest their courage should exceed
The bounds of moderation,
Between the seconds 'twas agreed,
To fix them each a station.

The distance stepped by Colonel P.,
'Twas only eight short paces;
Now gentlemen, said Colonel E.,
Be sure to keep your places.

Quoth H. to G., Sir please to fire,
Quote G., no pray begin sir;
And, truly, we must need admire
The temper they were in, sir.

We'll fire both at once, said H.,
And so they both presented;
No answer was returned by G.,
But silence, sir, consented.

They paused awhile, these gallant
 foes,
By turns politely grinning,
'Till after many cons and pros,
H. made a brisk beginning.

H. missed his mark but not his air,
The shot was well directed,
It saved them both from hurt and
 shame,
What more could be expected.

Then G. to show he meant no
 harm,
But hated jars and jangles,
His pistol fired across his arm,
From H. almost at angles.

H. now called upon by G.
To fire another shot, sir,
He smiled, and after that, quothe he,
No, truly, I cannot, sire.

Such honor did they both display,
They highly were commended,
And thus, in short, this gallant fray,
Without mischance was ended.

No fresh dispute, we may suppose,
Will e'er by them be started;
And now the chiefs, no longer foes,
Shook hands, and so they departed.

Henry William Hendricks. *Courtesy of Caroline McGregor Good.*

MEN OF VALOR

In December 1860, the South Carolina General Assembly began enacting the statutes that created a Confederate military. It is estimated that over sixty thousand South Carolina men of military age (eighteen to forty-five) responded to the call to arms and that one in every fourteen, or a staggering 35 percent, was killed or lost in action. This is one man's story.

The Charleston Regiment

Henry William Hendricks was not part of the Lowcountry aristocracy. His ancestors were among the Dutch adventurers who came with Hendrik Hudson in the early seventeenth century. They landed on Manhattan Island and were members of the original New Amsterdam colony. Little is known about these early immigrants, but later generations migrated to the Baltimore area. As the Maryland land grant belonged to Lord Baltimore, property records were transferred to England, and there is little available information about early landownership. Succeeding generations of Hendrix migrated to Missouri and Mocksville on the Yadkin, about ten miles from Salisbury, North Carolina.

The southern branch of the family was founded by Henry Hendrix, who later Anglicized his name. During the Revolution, the North Carolina Hendricks family distinguished itself by fighting with Francis Marion's

partisans. According to family tradition, they fought at Kings Mountain, Camden, Cowpens and Charles Town. Henry Hendricks fathered fifteen children, and his farm had the bad fortune to be in the path of Cornwallis's army. His farm was almost completely destroyed late in the Revolution, much to the despair of his large and hungry household.

Family records do not indicate how Hendricks ended up in South Carolina. Apparently, he and his second wife lacked the means to raise their children, for the Charleston Orphan House records indicate that Richard Frederick Hendricks (age seven) and Henry William Hendricks (age six) were placed in the institution on February 23, 1833. Little is known about Richard, who died during the Civil War, but Henry William was bound out to the U.S. Naval School in the days before the Annapolis Naval Academy. He had military training on the U.S. *Cyane* in the Pacific Station from 1841 to 1844.

At the outbreak of the Civil War, Henry William Hendricks was thirty-five years old, married to Cordrean Ackis, a descendant of Hogarth the painter, and was the father of three children with another on the way. For a number of years he had held the position of deputy sheriff. Hendricks joined the elite Twenty-seventh South Carolina Infantry Regiment in 1861. Charlestonians regarded the Twenty-seventh as their very own, and its ranks were filled with men from established Lowcountry families. It was generally regarded above other regiments in both social position and education. General Johnson Hagood described the Twenty-seventh in his memoirs as "not equal to some others in its discipline, but under his command would go anywhere and do anything…There was too much intelligence and too little rigidity of discipline in its ranks for men without force of character to command it successfully."[26]

The Twenty-seventh engaged in the Bombardment of Fort Sumter, fought at Secessionville on June 16, 1862, and was Taliaferro's mainstay at Fort Wagner on July 18, 1863. A portion of the regiment was in Eliott's garrison when the botched Union boat attack against Fort Sumter was repulsed in September of that same year.

When the Confederates abandoned Cole's Battery Island, Robert Smalls, a slave river pilot, commandeered the *Planter*, an armed Confederate military transport, and ran it past the Confederate forts guarding the harbor. Onboard the *Planter* were four artillery pieces, ordnance and a code book containing secret signals and placement of mines in Charleston Harbor. Smalls gave detailed information about the harbor's defenses to Admiral Samuel DuPont, commander of the blockading fleet.

Charleston orphanage on Calhoun Street. Over many protests, it was torn down to make way for a Sears Roebuck that is now part of the College of Charleston campus. *Courtesy Library of Congress.*

This intelligence convinced the commander of the Department of the South, Major General David Hunter, that the withdrawal provided an opportunity to land troops on James Island. He hastily assembled two divisions to attack Charleston from the south.

Under the protection of Union gunboats, 6,300 men landed on the southeastern end of James Island. The plan was to approach Charleston along the Stono River. Although there was light resistance, Hunter was convinced that he needed more troops before taking action. Brigadier General Henry W. Benham was placed in charge of the assault forces. He was given strict instructions not to advance until reinforcements arrived or he received specific instructions from headquarters.

The commander of the Confederate forces defending Charleston redeployed three batteries to James Island and ordered a buildup of

A youth serving aboard a United States naval vessel. *Courtesy Library of Congress.*

earthwork defenses to protect approaches to the island. One of the fortifications was at Secessionville with 750 troops under the command of Colonel T.G. Lamar. Shaped like the letter "M," the fort was bordered on each side by marsh. It was defended by nine cannons; two twenty-four-pounders at a flanking battery had not yet received their gun crews. Two hours' march away, the defending Confederate general, Nathan "Shanks" Evans, had placed three regiments of infantry (2,000 troops) in reserve in order to support any action on the island.

On the night of June 15, Lamar had his men working until 4:00 a.m. That same evening, General Benham decided to make an unauthorized "reconnaissance in force" on the fort. Benham planned a frontal assault before daybreak, attacking in two waves. Marched at double time, 3,500

Abstract of a cruise on the U.S. ship *Cyane* in the Pacific Station, 1841–44. *Courtesy Trott Papers, College of Charleston Special Collections Library, Charleston, South Carolina.*

troops crossed unfamiliar terrain. Navigating two hedgerows and a weed-choked cotton field in the dark caused the men to break formation. Some troops bogged down in the marshes. The rest were compressed in the center, slowing the advance to the extent that the second wave ran into the first.

The exhausted Confederates were alerted when Union soldiers encountered their pickets about 5:00 a.m. Forewarned, Colonel Lamar mounted the parapet and observed the Union front about seven hundred

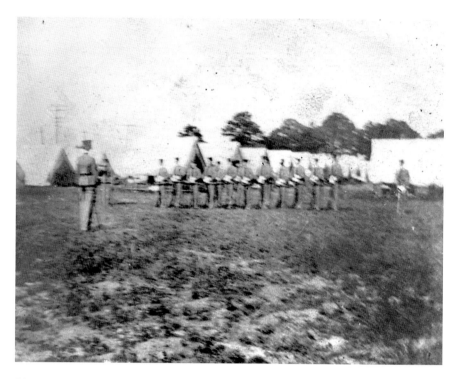

Citadel encampment. *Courtesy Middleton Papers, College of Charleston Special Collections Library, Charleston, South Carolina.*

yards away and moving. He immediately asked for a volunteer to deliver an emergency request for reinforcements.

By the time the Confederates assembled and began shooting, the advancing Union troops were scarcely two hundred yards distant. Colonel Lamar took charge of the center cannon and fired grapeshot, nails, iron chain and glass directly at the Union center, tearing a great hole in the advancing lines. The soldiers of the Seventy-ninth New York actually mounted the parapet and were engaged in hand-to-hand combat until Union artillery opened fire on the fort, forcing them to withdraw. The retreating men hampered the second wave from attacking.

Meanwhile, the men of the Third New Hampshire were attempting a flanking maneuver that brought them within several yards of the fort. The pluff mud and water impeded their crossing, so they shot across the marsh, driving the defenders from the parapets. During the assault, the two twenty-four-pounders on the right flank were silent, even though the gun crews were on line. Colonel Ellison Capers of the Twenty-fourth South Carolina

Infantry went to investigate and found that the men had never been trained. Capers started loading and firing the piece himself while training the gun crew. Two hundred fifty Confederate reinforcements arrived and poured heavy fire at the Third New Hampshire, causing them to fall back.

By 9:00 a.m., the Union forces had suffered such heavy losses that they withdrew. Union casualties were 689 (107 dead), compared to 207 casualties (52 dead) for the Confederates.

The official post-battle report praised the bravery of *all* defenders and mentioned in particular how Mr. Josiah Tennant of the Calhoun guard "felled six of the enemy." Captain William Ryan was commended for handling a twenty-four-pounder gun. Sergeant Henry William Hendricks and two others were mentioned for repeatedly bringing up ammunition through a heavy volume of enemy musketry. Hendricks had also been dispatched to direct the movements of the Louisiana Battalion as they approached the battle under heavy fire. He succeeded without receiving the slightest injury and resumed his place at the battery. The report called it "a gallant and daring feat, eliciting the admiration of both men and officers." Hendricks later told his family that bullets were flying around him as thick as hail as he dashed across the open field. When he passed a well, his first impulse was to jump in, but he continued on. This decision may have saved his life, for as he rushed by, he saw a shell explode in the well.

Three days after the fiasco at Secessionville, General Benham was arrested. The Judge Advocate General's Office recommended revocation of his commission, but the Lincoln administration rescinded it, as Hunter possessed an aggressiveness that most Union generals lacked in 1862. Benham fought with Grant in Vicksburg and in the Virginia campaign in 1864.

Hendricks went on to make his first captures at Battery Wagner, where he received the sword of New Hampshire lieutenant colonel Bedell and took another trophy, the saddle of the adjutant general engaged in the assault.

The Brigade Goes North

Colonel Johnson Hagood fought with such gallantry at Secessionville that he was promoted to brigadier general. His brigade went to Virginia in 1864 and fought at Drury's Bluff (also spelled Drewry's Bluff), Cold Harbor, Bermuda Hundred, Whitehall Junction and Weldon Road. The Twenty-seventh

served in the entrenchments during the Siege of Petersburg until December 1864, when it was ordered to the relief of Fort Fisher. Lieutenant Hendricks participated in most of these engagements and recorded his experiences in a diary that dated from April 1864 to March 1865.

When Captain Brown was killed in the trenches in Petersburg, Hendricks was promoted to captain, a position that he retained until the end of the war. At one time, he was the only officer in his company who had not been killed or taken prisoner.

In his diary, Hendricks describes the nine-day journey from Charleston to Petersburg, Virginia. The troops were almost immediately engaged in skirmishes, and within a week, they had fought at the massive fort on Drury's Bluff. Afterward, they pursued the retreating enemy, fighting at Bermuda Hundred in mid-May and on to Cold Harbor on May 31. He described the dead Yankees lying for three days between the two camps at Bermuda Hundred, catching "two grey backs" on his clothes, having a "fine wash," writing his wife and eating a good steak when a deer was shot. Interestingly, the pickets in both camps wanted to trade tobacco for sugar and coffee, but the Southerners were not allowed to trade or communicate with the enemy.

Hendricks gave a daily account of the Battle of Cold Harbor, remembered as one of the bloodiest battles of the war. The two armies faced each other for nine grueling days of trench warfare. The trenches were hot, dusty and miserable. By the third day, Hendricks wrote that a North Carolina Confederate major raised a white flag to surrender. He was shot at by his own colonel, and when that shot missed, the colonel ordered his men to shoot him down. The fighting was fierce, with many dead lying between the two opposing forces. Although Lee offered Grant a flag of truce to bury his dead, Grant refused because he did not want to signal that he had lost the battle. As a result, the wounded waved their hands asking for help for three days before they, too, became bloated corpses. Hendricks described General Grant as an "old brute." It is estimated that the Union lost somewhere between 7,000 and 13,000 men compared to Lee's 1,000 to 1,500.

The Twenty-seventh was redeployed to Petersburg. Hendricks was hospitalized with a fever and was sent by train to a Raleigh hospital, "a mean place with straw beds full of bed bugs." He was later transferred to Columbia, which he described as "one of the last places God has allowed to be called a hospital." He was released at the end of June and sent to Weldon by train.

With the rails torn up, the men were forced to march the last twenty-five miles to Petersburg. The road was dusty, and they had nothing to

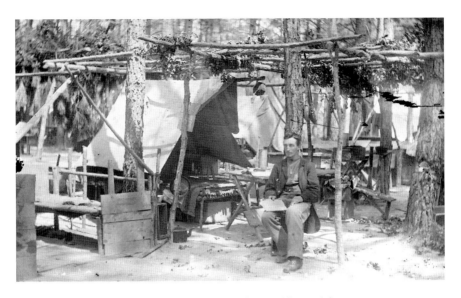

Confederate headquarters, Petersburg, Virginia. *Courtesy Library of Congress.*

eat, for the local farmers were starving. Back in the trenches on July 9, the men were given a small piece of bacon, three spoons of corn bread and a spoonful of rice for the day. The food supply was so meager that sometimes rations were stolen. Heavy rains caused the trenches to become "as near a hog pen as it is possible for them to be. I sleep on logs tonight to keep myself off the ground," Hendricks reported. Being constantly shelled by the enemy and the harsh conditions affected Hendricks's health, and within two weeks he was back in the infirmary, where he ate "the best meals in the past six months."

Returning to the front, he described always feeling sick, correspondence with his family and the tedium of trench warfare: fatigue duty, intense heat, poor rations, intermittent fighting. On one occasion when going to the front after a rainstorm, the men forded rushing water that came up to their armpits; another time, General Hagood ordered a drain dug to draw water from flooded trenches.

In early August, the troops were deployed to Weldon to recapture a portion of the railroad that linked Petersburg and Richmond with Wilmington and Charleston. On August 4, Hendricks was captured and taken to "Yankeeland." Although he didn't know it at the time, this probably saved his life, for the Twenty-seventh's heroic charge occurred twenty days later.

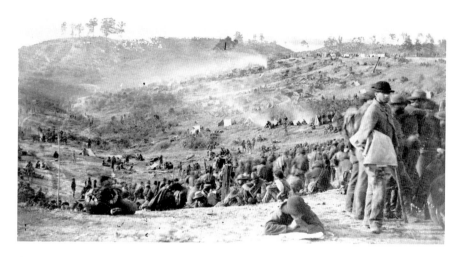

Confederate prisoners captured in Virginia. *Courtesy Library of Congress.*

Before approaching Weldon, General Hagood had been assured that no fieldworks had been established, but when his men came out of the woods, they discovered rifle pits and heavily manned earthworks. The discovery was made too late. The Rebel yell rang out loud and clear, and under heavy fire, determined men cleared the rifle pits. Without reinforcements, the men were trapped as the enemy approached from all sides. Once the standard-bearers had all been killed, Union captain Daly of General Butler's staff rode out and took possession of the brigade's colors. Escape seemed hopeless, and he urged the Confederates to surrender. General Hagood stepped boldly forward, demanded the colors back and offered Daly safe passage back to his lines. When he refused, Hagood shot him, and as Daly fell from his horse, the general leaped into the empty saddle while tossing the colors to Dwight Stoney.

The men of the brigade rallied and fought their way back through withering firepower. The Federal line to the rear collapsed as they charged through it. When Hagood's horse was killed, he led his men on foot back across half a mile of open field while deadly Federal fire pursued them all the way to the cover of the swamp. Of the 740 men who made the charge, 273 returned to the Confederate lines.

While his regiment was preparing for Weldon, Hendricks and other prisoners were taken to Fort McHenry near Baltimore. From there, they were transported to the Old Capitol Prison in Washington. They were not allowed to look out of the windows; a sentinel below would shoot at them if they were caught. The famous Confederate spy Belle Boyd was imprisoned while Hendricks was there, and she was shot in the arm for the same infraction. The men were soon transferred to a prison in Philadelphia that was full of lice and bedbugs.

Within eight days of their capture, the prisoners found themselves in the notorious Fort Delaware on Pea Patch Island. It was a forbidding place that had been enlarged just before the war. The exterior walls were made of solid granite blocks, which were surrounded by a moat and drawbridge. The prisoners were housed in overcrowded brick barracks. About 2,700 of the 12,500 prisoners who were incarcerated at the fort died, and many were buried at Finn's Point, New Jersey, just across the Delaware River.

Fort Delaware was a muddy, vermin-infested place manned with the guards who were "very low fellows for soldiers." On one occasion, the guards made three officers walk up and down the yard on the double quick for two hours at the point of bayonets. The only food provided was slops, stale bread, half-done beans and water soup. Hendricks commented that "the men could not live on such grub, was it not for what they could buy from the Sutler." Those without money from home were literally starving to death.

To survive, prisoners resorted to catching and frying rats and fishing for catfish in the open "sinks" where the men relieved themselves. Many became so sick that they used quart bottles for chamber pots, as the walk to the sinks was too exhausting. They passed the time playing cards, pitching horseshoes, shooting marbles, catching catfish and killing rats. Conditions were so deplorable that someone exclaimed, "There was no Hell," echoing the very words of Andersonville prisoners who were crowded into a filthy Georgia stockade where almost a quarter of the prisoners died from malnutrition, dysentery and exposure.

On September 16, the barracks walls at Fort Delaware were whitewashed, and Hendricks commented that he hoped that it would help rid the barracks of lice. Three weeks later, the two sides began exchanging prisoners. Hendricks knew that when the offer for exchange was made, the sick prisoners would be exchanged first. Before the surgeons examined him, he licked the newly painted wall and thoroughly coated his tongue with whitewash. When the surgeon examined him, he declared, "He'll die in three weeks," and ordered him released. Hendricks was paroled thirty-five days after his arrival.

Hendricks passed his thirty-eighth birthday at Atkins Landing en route to Charleston. Their transport had a band onboard, and the men could hardly keep from crying at the sight of the Confederate flag. Hendricks was furloughed for two months. His diary is touchingly silent during his leave, but family records show that his fifth child was born on December 14, just five days before he was ordered to rejoin his brigade. It must have been very difficult leaving a convalescing wife and children.

December 19, 1864, found Hendricks back with his men as they headed to defend Wilmington, North Carolina. The cold weather and trees encrusted with ice matched his dour mood. On Christmas Day, they were on a steamer headed down the Cape Fear River in a rain that drenched to the skin. Hendricks made several entries about renegade Confederates who shamefully destroyed civilian household property and wantonly killed civilian livestock, leaving the carcasses rotting in the open fields. The cold rain continued intermittently as the men made a hard fifteen-mile march through the "meanest country we have been through." By the time they reached their destination, the men were caked with mud. Hendricks and some of his men got sick once again.

After a brief sojourn in the encampment near Wilmington, the regiment was ordered to the heavily fortified Cape Fear River, the last bastion of Southern resistance. They witnessed the fall of mighty Fort Fisher, largest of the Confederate forts. Built mostly of soil, the fort's structure was efficient at absorbing attacks from heavy artillery. In 1863, more than one thousand individuals had toiled to expand the fortifications. In 1864, the Thirty-sixth North Carolina Regiment was quartered inside. Approaching Union battleships could not avoid the fort, and they were forced to remain far from the shoreline because of coastal artillery. Wilmington was the Confederacy's last open port, and both sides knew that if the Cape Fear defenses fell, the Southern cause was doomed.

On January 12, 1865, an armada of fifty-six Union ships began bombarding Fort Fisher in the largest amphibious operation prior to World War II. Eight thousand soldiers landed on January 15 and entered the massive fortification. The Confederates found themselves battling behind their own walls and were forced to retreat. They blew up forts on the north side of the river before crossing to defend Fort Anderson, another pivotal fortification protecting Wilmington.

By January 15, Hendricks had a miserable chest cold that was compounded by the demoralizing battle losses and news of the evacuation of Charleston. The men were near starving but feared almost certain death or capture if

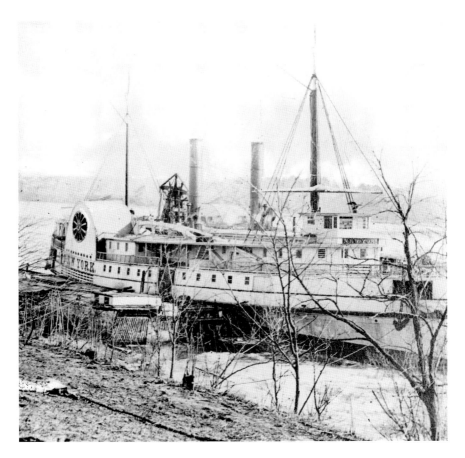

A Union prison ship. *Courtesy Library of Congress.*

they left their protected positions. On February 20, Hendricks was captured again; he was taken to Fort Anderson, where it was galling to hear his captors "crow" about the fall of Charleston and the news that the war would probably end in a couple of days. (After the fall of Fort Fisher, the South's trading route was cut, and the war officially ended three months later.)

On February 23, Hendricks was put aboard a prisoner transport named *Tonawanda*. The men became seasick as the ship tossed in an overnight storm. It was a difficult trip. Over five hundred men were crowded in a hold that reeked of vomit and the stench of human waste. Only two men were allowed on deck at a time. As a result, the rest of the men were forced to "do their business" in two barrels. During a storm, these barrels overturned and dumped their contents onto the men who were lying nearby. Hendricks commented that the hold reminded him of the slave trade and its attendant

hardships. It was four days before the wretched ship reached Fortress Munro and was cleaned up by the prisoners.

The Confederate captives were taken to the Old Capitol Prison in Washington just before Lincoln's inaugural celebration. They were treated as badly as before, this time for revenge for the way the Yankee prisoners were treated in Andersonville. Hendricks continued to feel sick and complained about the skimpy rations and the bleakness of the cause. On March 3, he witnessed the execution of a Yankee sergeant who had raped and murdered an eight-year-old girl. He was shot in the prison yard, and Hendricks commented that in spite of his crimes, the soldier "died like a man."

Hendricks wrote about the guns firing during the inauguration ceremonies, the presidential ball and a church service attended by three Yankee ladies. Mundane comments about his health, food, the weather and being able to wash filled most of the remaining entries. Diary entries stop on March 9, 1865.

South Carolina after the War

Once the richest state in the nation, South Carolina lost everything in the War of Secession. The state lost a generation of men, and hundreds of veterans returned permanently disabled. The years of destruction left many destitute and desperate. As described by Charleston's farsighted Episcopal minister, the Reverend A. Toomer Porter:

> The entire wealth of the state had been swept away and all schools existing in 1861…The wresting of our slaves from us, involved the depreciation of our land; railroads had been destroyed, banks had failed, factories we had none; insurance companies had all failed. There was, therefore, no source of income and the most calamitous result was the inability to educate our children…Unhappy is the land with no educated, cultured class. If everything is on a low dead level, then ignorance and deterioration are inevitable.[27]

The economic and social misery was compounded by the fact that the victors regarded South Carolina as the cradle of rebellion. Washington imposed a humiliating defeat. Not only did the returning veterans have to swear an oath of allegiance to the United States, but opportunistic

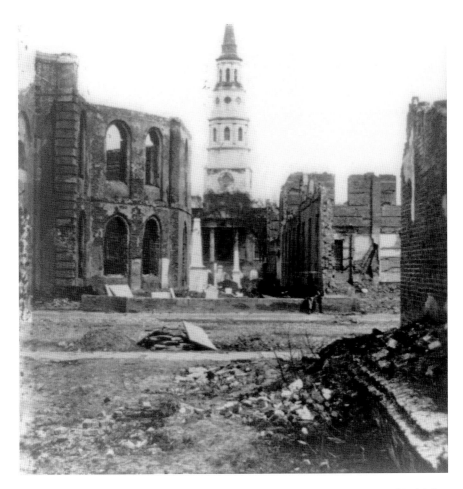

Ruins of the Circular Church and Secession Hall on Meeting Street. St. Philip's Church is in the background. *Courtesy Library of Congress.*

Northerners, known as carpetbaggers, flocked south and participated in wholesale corruption. They were joined by local Republican "scalawags" who took advantage of the economic opportunities and lined their pockets at the public trough. In *The Tragic Era, The Revolution after Lincoln*, Claude G. Bowers commented:

> *Never have American public men in responsible positions, directing the destiny of the Nation, been so brutal, hypocritical, and corrupt. The Constitution was treated as a doormat on which politicians and army officers wiped their feet after wading in the muck. Never has the Supreme*

*Court been treated with such ineffable contempt, and never has that
tribunal so often cringed before the clamor of the mob. So appalling is the
picture of these revolutionary years that even historians have preferred to
overlook many essential things…The Southern people literally were put
to the torture.*[28]

By 1868, South Carolina had a new constitution. Between 1867 and 1876,
black Republicans were elected to 52 percent of the state and federal offices.
This era, known as Reconstruction, was a period of such privation and
despair that it was still discussed in many white southern homes well past the
middle of the twentieth century. Corruption was what finally brought about
the demise of the Republican Party in South Carolina.

Throughout the decade after the war, there were enormous tensions
between the emancipated slaves and the white population. Racial violence
across South Carolina had escalated to such an extent that in 1871, President
Grant issued a proclamation for all armed groups to disband and declared
Chester, Chesterfield, Fairfield, Lancaster, Laurens, Marion, Newberry,
Spartanburg and York Counties to be in rebellion. When Franklin J.
Moses, known as "the robber governor," was elected governor in 1872,
former Confederate general Wade Hampton said that it was time for white
southerners to dedicate themselves to the redemption of the South.

Although moderates had first allied themselves with the ruling
Republicans, by September 1876, the Democratic Party was organized and
Hampton was its nominee for governor. Hampton made a triumphal sweep
across the state, accompanied by the famous mounted "Red Shirts." It was
the only campaign in which rich and poor alike banded together for the
common goal of ridding the state of the detested army of occupation and
the corruption it permitted. Some of Hampton's supporters were black,
and they were treated so threateningly by their own people that the Red
Shirts had to protect them from violence. The November election was full
of voting irregularities on both sides; both camps claimed victory. Heated
emotions led to a major race riot in Charleston.

On November 8, the day after the election, E.W.M. Mackey, a politically
influential and staunch white Republican, gleefully read the favorable
election results to a group of illiterate black Republicans assembled at the
public bulletin board on Broad Street. Once finished, Mackey left the group
and proceeded down the street. In rare good spirits, he got into a discussion
with a group of white men in front of the *News and Courier*'s Broad Street
office. A half-drunk man was disgusted and struck him in the face with a

The Citadel seen across Marion Square. *Courtesy Library of Congress.*

hat. A shot was accidentally fired, and blacks at the outskirts of the crowd thought that Mackey had been murdered. They gave the alarm, and in less than five minutes a mob was surging down Broad Street, accompanied by a number of black policemen who had apparently decided that it was time to slaughter whites.

In spite of attempts to restore order, the renegade policemen broke into the "main guard house," where they snatched up Winchester rifles and began shooting at every white man in sight. The first victim was Endicott Walker, a popular young businessman, who was returning to work after dinner. Farther down Broad Street, more than one thousand blacks began firing pistols and other weapons near the courthouse square. The mob stormed the door of the station house, howling, "Give us guns!" They were held at the door by Chief of Police Hendricks and a few loyal men.

The riot was finally quelled when five hundred members of various rifle clubs and Federal troops quartered at the Citadel Green joined ranks and took back control of the city. As described by an eyewitness fifty years later, "People of this day can hardly understand the terror and the horror of those negro riots, of which I can recall four within three years, with the very worst and grossest of the black men thronging the streets, armed, infuriated, secretly incited to hate and blood thirst and lust, with two-thirds of the police force ready to aid them."[29]

The chief of police mentioned in *Hampton and His Red Shirts* was Captain H.W. Hendricks of the Twenty-seventh Regiment. When the war ended, for a short time he was a messenger in the National Express Company under the former Confederate general Joseph P. Johnston.

With a family to feed, he risked the censure of his contemporaries when he became associated with the police department during Republican rule. In time, his skill at municipal politics earned him the respect of friend and

The Hendricks home at 206 Hibben Street in Mount Pleasant. *Courtesy of Caroline McGregor Good.*

former foe alike. He was second and afterward first lieutenant of police under Mayor Gaillard, his Confederate commander, and first lieutenant of police under both General Burns and General Cogswell. He was elected chief of police under Mayor G.W. Clark and again under Mayor Pillsbury. He was made deputy marshal by Colonel R.M. Wallace, and in 1873 he was elected chief of police under Mayor G.I. Cunningham, a position he still held at the time of the 1876 riot.

After the election of 1876, people wanted to rid themselves of the incumbent Republicans as quickly as possible. Some held Chief of Police Hendricks accountable for the disastrous post-election riot, claiming that he had protected the blacks who went on the rampage. This did not go down well with responsible citizens of Charleston. By December 1877, roughly two hundred men representing various professional, commercial and industrial interests recommended in a printed pamphlet that Chief of Police Hendricks be retained, stating that they had no "other motive than the welfare of the City and attested their names in appreciation of the valuable services he has rendered in the past." The pamphlet contained a letter of commendation from General Johnson Hagood and another from General Connor, attorney general of South Carolina. A handwritten three-page letter was written on his behalf by P.C. Gaillard, ex-colonel of the Twenty-seventh Regiment and former mayor of Charleston.

Although Hendricks was regarded as a shrewd politician, his affiliation with the Republican Party made him many enemies. He defended his actions and tried to explain to his family that he had allied himself with the Republican Party as "a matter of bread," for they would have starved otherwise.

Hendricks became chief United States deputy marshal for South Carolina, capping a long and productive career in public service. His family remembered him as a kind father, an outspoken foe and a staunch friend. He died in 1898 in the seventy-second year of his life at his home in Mount Pleasant. He is buried in Magnolia Cemetery.

THE PROMISE

Confederate captain Hendricks kept a war diary when his regiment went north to protect Richmond in 1864–65. The diary is strangely silent about a kindness to a dying Yankee lieutenant. The young man was the son of Judge Halsey R. Wing of Glens Falls, New York. Both of the judge's sons had enlisted in the One Hundred and Eighteenth New York Volunteers when the call to arms came. In 1868, Lieutenant George H. Wing died at Covington, Kentucky, of a disease he contracted while a Confederate prisoner. The other son, Lieutenant Edgar C. Wing, was mortally wounded at Drury's Bluff, Virginia, on April 16, 1864. According to General Humphreys in his *Campaigns of 1864–6*, it was one of the fiercest battles of the war.

In the cleanup after the battle, Captain Hendricks found the stricken lieutenant lying among the dead and asked if there were anything that he could do for him. Knowing full well that he must soon die, Lieutenant Wing requested that Hendricks return his sword and watch to Judge Wing. He told Hendricks that the sword was a gift from his father, who had desired him to use it bravely and preserve it as a family treasure. He provided his father's address and offered money, which Hendricks refused, saying that Wing might need it at the hospital. Hendricks called for a stretcher and had him sent to the rear. The two parted, never to meet again.

Lieutenant Wing was sent to a field hospital and later put on a boat of Confederate wounded bound for Richmond. While onboard, a Mr. Stokes talked to him until late in the evening. Finding that the young man had died before dawn, Stokes made arrangements for Wing's burial, marked the grave

site and contacted Judge Wing in Glens Falls. After the war, the judge went south and, with Stokes's assistance, found his son's grave. He brought the body back home for a proper burial in the village cemetery. A monument to Lieutenant Wing was erected in the Glens Falls town square. Because of the solicitude of the two southern gentlemen, thought to be Masons, thereafter Wing's family cherished "very kindly feelings towards the South."

For safekeeping, Hendricks sent the sword to his wife in South Carolina. In true southern tradition, she regarded its return to the Wing family as a sacred trust that involved her husband's honor and her own.

Like most southern women, Cordrean Ackis Hendricks had already been forced to endure a lot after "the flower of the South" volunteered to serve in the Confederate army. The blockade stranglehold had begun to take effect, and communications with the war front were so poor that often families had little news of their absent loved ones. In addition to her husband, both of her brothers, Richard and James Ackis, had enlisted almost immediately. They had gone north and fought in Rhett's Battery at the Battle of Gettysburg.

Corporal Richard Ackis's head was shot off on July 3, 1863, and his body was left on the battlefield as the fighting raged around his decapitated corpse. His brother James was more fortunate. After a bullet entered his chin and went through his windpipe, he was carried to a barn with other Confederate wounded and left there for three or four days before Federal scouts came upon them.

Expecting the worst from his captors, Ackis later told the family that he was well treated by the women of Gettysburg, who followed the Biblical injunction "return good for evil." He was sent by rail to Baltimore, where his "youthful appearance and blood besmirched clothing excited sympathy" from the ladies who attended the wounded. This kind treatment continued when he was sent to a hospital in Chester, Pennsylvania. There he was "lionized as a youthful rebel from the cradle of secession." He recovered from his wounds and was paroled. He was exchanged about a month later and went on to fight with Longstreet until he was once again captured. This time he was held prisoner at Point Lookout, Maryland. Although overcrowded, this prison camp was far better than most. He remained there until hostilities ceased.[30]

By the time Lieutenant Wing's sword arrived from Virginia, Cordrean Hendricks had already lost one brother and feared for the safety of the other men in her family. She was expecting another child when her husband was captured on August 4, 1864. Hendricks was exchanged two months before

their fourth child was born and went home on leave. It must have been very difficult for everyone when he returned to duty just before Christmas, leaving a convalescing wife and an infant less than a week old.

And there were other concerns. As the year ended, the war news grew worse and worse for the Southern cause. Sherman completed his infamous "March to the Sea" in late 1864 and was amassing a huge army in Georgia. In February, he crossed into South Carolina with sixty thousand men. Fearing that Charleston, the "cradle of secession," would soon fall, many fled the city. While Captain Hendricks was marching to Fort Fisher, his family joined the refugees who ended up in Columbia. Thinking that her family treasures would be safe from the invading army, Cordrean honored her husband's promise and added Wing's sword, sash and belt to the valuables that she took to Columbia.

The house where the Hendricks family sought refuge was built on a hill. On February 16, when reports of the enemy got more menacing, Cordrean decided to bury her silver, jewelry and other valuables. Concerned that the servants would betray her, she waited until after midnight, when everyone was asleep, before she crawled on her hands and knees beneath the porch. In the pitch black stillness, she used makeshift tools to scrape a hole large enough to conceal a small trunk. She wrapped the sword in a blanket, covered it with oilcloth and placed it in the shallow trench. It was such a difficult task that she had to take her fifteen-year-old daughter Amanda, affectionately known as Manny, into her confidence.

As it turned out, Cordrean and her family would have been better off had they remained at their home in Mount Pleasant. Sherman's army sacked and burned Columbia the following day. In the mayhem that followed, Wing's sword became Manny's personal charge. She secreted it against the peril of capture, for it would have been a prize for the soldiers of either side.

The war finally ended. The captain's family was scattered and did not know if he had fallen in the conflict. There was a separation for a long time.

Picking up the pieces of their lives was extremely difficult for the defeated Confederates. Their land was occupied by armed soldiers, their government was run by a host of opportunists who had swarmed in like feasting locusts and a new civil government had been imposed.

Hendricks finally returned. As he had been a deputy sheriff prior to the war, in order to feed his family, he once again worked for the police department. He made inquiries about the location of Wing's family, but Glens Falls was unknown to people in South Carolina's Reconstruction government, and other more pressing matters took precedence.

Time passed. Two more children were born to the Hendricks family. Manny grew to become a beautiful young woman with large brown eyes, dark hair and a sweet disposition. She married Daniel Sinclair in 1870 and had a daughter who died in infancy.

In 1882, Hendricks received a letter from Captain Louis F. Emilio of New York City. Emilio had been one of the white officers in charge of the Fifty-fourth Regiment of Massachusetts Volunteers, serving with the regiment from recruitment through disbandment. Emilio had fought at the assault on Battery Wagner, one of the forts protecting Charleston Harbor. The assault at Battery Wagner had little significance militarily, but it had a huge impact on the North. It had proven that African American troops could, and would, fight for their country; almost 200,000 fought for the Union. After the war, Emilio had taken up the cause of the Fifty-fourth and spent years researching and writing about their experiences.

During the Siege of Charleston, General Quincy Gillmore had been in command of the Department of the South and ordered that his forces be integrated. African Americans were no longer assigned only menial tasks such as latrine duty and KP but instead were to carry arms into battle. The forces that made the failed assault on Fort Wagner were under his command. When the white officer who led the assault, Colonel Robert Shaw, son of a Massachusetts abolitionist family, was killed, Emilio became the acting commander of the Fifty-fourth.

Due to the sweltering July heat, Confederate general Johnson Hagood had ordered burial as quickly as possible. Colonel Shaw's corpse was treated shamefully by some of the Confederate soldiers. His body was stripped of its uniform and placed in a common trench beneath his black soldiers. In the North, some were so scandalized at the way Shaw's corpse was treated that they tried to have his body exhumed and buried with full military honors. Only the intervention by Shaw's father put an end to the outcry.

As Hendricks had fought at Battery Wagner, it was only natural that Emilio eventually contacted him. Hendricks had witnessed Shaw's burial and later provided the following for Emilio's book: "This desecration of the dead we endeavored to provide against; but at that time…our men were so frenzied that it was next to impossible to guard against it," explaining that Shaw's desecration was "by the more desperate and lower class of our troops."[31]

Emilio had also spent years trying to trace the effects of Edgar Wing, who had been his personal friend. You can imagine Emilio's delight when

his correspondence included the following from Hendricks: "I have in my keeping a sword and sash, the property of Lieutenant Edgar M. Wing of Glens Falls, N.Y. I also had his watch up to my capture, but of which I was quickly relieved when I was made a prisoner. The sword and sash are in good preservation, and I am anxious to return them to some member of his family. Can you assist me?"

By then, Hendricks had given his Confederate uniform and sword to his eldest daughter, along with the safekeeping of Lieutenant Wing's sword. Once she had the address, Manny wrote the lieutenant's sister, Angie C. Wing. The two women made arrangements for the transfer, and in time the "lost" sword was finally hung above the library mantel in the Wing mansion in Glens Falls.

Returning the sword changed the life of Manny Sinclair. In 1882, she was thirty-two years old and a widow with few prospects in the impoverished South. Money was scarce, and times were still exceedingly tough for most of the former Confederates. The only things they had in abundance were family pride and their sense of honor.

Manny invited Angie Wing to visit the Hendricks family in Mount Pleasant, and she accepted. Angie Wing was remembered as a tiny woman with reddish hair and considerable wealth. It was the custom in those times for wealthy unmarried women to have female companions, usually young women from respectable families who were in reduced circumstances. According to family tradition, Miss Wing "fell in love with Manny and practically adopted her."

The women traveled extensively together. In August 1891, they made arrangements to be in Lake George when the GAR "Post Wing," the old "Adirondack" One Hundred and Eighteenth Irish New York, held its annual reunion. The event is described in an August 20 letter addressed to the editor of the *Tribune*, Lake George, New York. After mentioning the dignitaries and a speech about how the sword was given to Captain Hendricks and later returned to the Wing family, the article continued:

> *The Warren County Veterans camped in Fernwood Grove just across from the Fernwood Cottage…a lady guest of Fernwood Cottage sat at an upper window listening to the speech. She was Mrs. Sinclair, of Charleston, the daughter of Captain Hendricks and the preserver and restorer of this sword. The fact became known to the camp and created interest and feeling. The touching incident and the rare chance coincidences of the heroine's nearness after so many years, to the assembled*

survivors of the dead lieutenant's comrades had a most tender and melting effect upon the camp.

A campfire council was held that night and it was enthusiastically decided to show in some way the veteran's appreciation of this beautiful fidelity by one who wore the enemy's uniform and followed the enemy's flag. The next morning the veterans of the 118 New York Volunteers… followed by all the veterans of the camp, citizens and Lake George visitors, headed by the Citizen Corps band of Glens Falls, marched to the grounds of Fernwood Cottage, the veterans forming in front of the piazza [porch].

Colonel Cunningham, also of the 118, soon appeared on the piazza with Mrs. Sinclair and fellow-guests of the cottage. He touchingly rehearsed an account of the battle and the story of the sword, and dwelt upon its sweetness and peaceful significance, "like finding a nest full of young birds in an old cannon's mouth, or a blossom clinging to a lightning seared oak"—its present effect on these old soldier hearts and their desire not to break ranks until they had paid their homage and grateful respects to this fair daughter of her manly father. The address was tender, impressive and delicate, and during its delivery the tears not only coursed down the honored lady's cheeks, but brought many a coat sleeve across the eyes of the old veterans. A brief but apt response was made by one of the lady's gentlemen friends, when Mrs. Sinclair was introduced and graciously bowed her acknowledgements [she received] *a vociferous "three times three and a tiger." The veterans then passed by in single file and warmly shook the lady by the hand, while many spoke out, "God bless you" and other tender and respectful salutations indicated the depth of feeling with which these old hearts were struggling. It was such an impressive scene that it was almost solemn in the intense silence of the on-looking crowd…*

Mrs. Sinclair was afterward unanimously elected an honorary member of the Veterans' association and presented with the badges of the association and of the 118 New York Volunteers, and later a photograph of the veterans formed in a semi-circle with this lady and her special friends in their midst, was taken and christened "The Angel of Peace."[32]

Miss Wing established a home in Summerville, South Carolina, and lived there with Alice Hendricks, one of the captain's two surviving daughters. Angie Wing was a Presbyterian who taught Sunday school and

was deeply interested in foreign missions. The Wings were so grateful to the Hendricks family that in 1910 they deeded Alice Hendricks a building lot in the Presbyterian Conference Center in Montreat, North Carolina.

On July 31, 1892, the *New York Times* published an article entitled "Read the Union Signals, Mr. Lowndes Valuable Services to the Confederacy." It describes an interview with T. Pinckney Lowndes at a dinner welcoming the North Atlantic squadron to Charleston. Excerpts are quoted below:

> *Mr. Lowndes…was in the opinion of men who know, one of the most expert signal officers the Confederacy possessed. His service was confined almost entirely to the operations in and about Charleston, and in the duty he performed in Fort Sumter and in the batteries on Sullivan's Island and John's Island, his remarkable expertness in intercepting and deciphering the Union signals blocked many a plan which need only secrecy of preparation to assure success.*
>
> *The first Union signal intercepted by Lowndes was a wig-wag message from the new ironsides iron-clad to Morris Island…from Admiral Dahlgren to General Gillmore. The message related to the massing of the small boats of the fleet in Lighthouse inlet for the conveyance of troops to a designated point on Morris Island. It was read by Lowndes from Fort Sumter. The distinction of first intercepting a Union signal cast on the enterprising officer the responsible as well as arduous duty of watching on the parapet of Fort Sumter without relief for four days and nights consecutively.*
>
> *When asked by the* Times *correspondent, Mr. Lowndes said that the first key to the Federal signals was obtained through a ruse practiced upon some Federal signal men captured on John's Island. A confederate officer, Major K. Pliny Bryan, was placed among the prisoners disguised as one of their own people. Shortly afterward, a supposed key was furnished to Lowndes, which after a few corrections, unraveled the mystery of the Federal signals…The most difficult part of interpreting signals, Mr. Lowndes declared, was the determining whether the signal operator had his face or back to him. It necessitated a double reading often, in order to insure the obtaining of something tangible.*

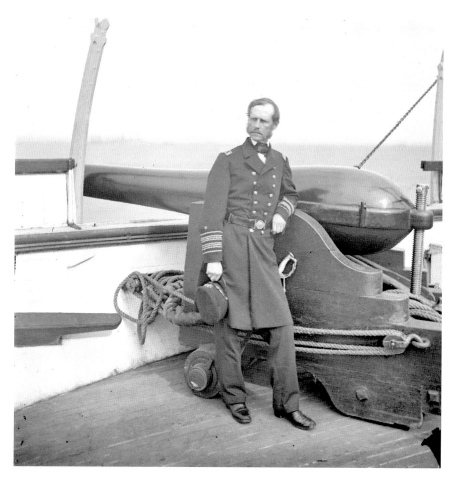

Rear Admiral John A. Dahlgren in Charleston Harbor onboard the USS *Pawnee* standing beside a Dahlgren gun. *Courtesy Library of Congress.*

The announcement of the Federal intention to assault Battery Wagner was conveyed to the Confederates in the following signal, which was intercepted by signalman Millard, a Sergeant in Lowndes' corps…July 16, 1863, 4:55 p.m… "Keep your infantry under arms; the men must remain in line. The island is filled with stragglers." [and another message] *"An assault is ordered at dusk. Husband your ammunition, so as to deliver a rapid fire the last half hour."*

Knowledge of the foregoing signals enabled the Confederates to make every possible preparation, and by 10 o'clock that night 2,000 Union

men lay dead and dying in the trenches of Wagner, among the number being the gallant Shaw, unrecognizable among the slain of the Fifty-fourth Massachusetts.

Rear Admiral John A. Dahlgren headed the Union navy's ordnance department and designed several different kinds of guns before being given command of the South Atlantic Blockading Squadron in 1863. Thinking that Fort Sumter was poorly manned, General Gillmore and Admiral Dahlgren decided to take it the night of September 8–9, 1863. Wanting to claim credit for the navy, Dahlgren refused to put his men under the command of an army officer, so two flotillas headed for the fort. Low tide detained the army flotilla off Morris Island; by the time they could proceed, the naval assault had already been defeated.

Although Admiral Dahlgren had a penchant for intelligence gathering and personally questioned escaped Union prisoners and Confederate deserters brought aboard his flagship, he did not realize that the signal flag code used to communicate between the fleet and the army had been compromised. Dahlgren was rowed to a position near the fort to observe Commodore Stevens's attack with thirty boats carrying three hundred sailors and one hundred marines. The Confederates held their fire until the boats were nearly ashore and then opened on the exposed Yankees with everything from hand grenades to the guns of CSS *Chicora*. The Federal naval attack was repulsed; seventy sailors and thirty marines were taken prisoner.[33]

Assault on Myrtle Grove

Clan Gregor

By the time of the American Revolution, many Scots had immigrated to the southern colonies. After the disastrous Jacobite uprisings, waves of impoverished, desperate Highlanders fled to both North Carolina and Georgia. When the English Parliament outlawed the clan system after Bonnie Prince Charlie's defeat at Culloden Moor in 1746, Highlanders were prosecuted and persecuted for supporting the Stuart claims to the throne. Wearing the tartan was a penal offense.

In contrast to the Highland immigrants, the sons of educated and privileged Lowlanders and Protestant Dissenters were attracted to the religious freedoms and social system set up by the Lords Proprietors in South Carolina. Many Scots quickly joined Charles Town's ruling elite. They established schools and churches to entice immigration of their countrymen. In 1729, the St. Andrew's Society was founded to provide for indigent Scots. In 1804, the St. Andrew's Society opened a school for the poor and children of members who had fallen on hard times. Membership in the society included both Scots and other prominent community leaders. The St. Andrew's Society later constructed the social hall that was used for the Secession Convention, where the adoption of the Ordinance of Secession on December 20, 1860, changed the old South forever.[34]

Dr. John Moultrie, Robert Pringle and Governor James Glen are some of the better-known early arrivals, but other Scottish families are equally interesting. One such family was part of the Clan Gregor, which had a lineage that can be traced back to the eighth century, when Scotland was still ruled by the Scots and Picts. The MacGregor motto was "Royal is my race," and they claimed descent from early kings. During a twelfth-century hunting party, a strapping Sir Malcolm became Lord MacGregor after boldly saving the king from an attack by an injured wild boar.

The MacGregors were one of the Highlands' most famous clans. Over the centuries, they were engaged in numerous conflicts over their ancestral lands that Robert the Bruce had granted the chief of Clan Campbell. Eventually, the MacGregors were dispossessed of all hereditary lands. They were declared outlaws after killing two hundred Colquhouns in a 1603 battle, and use of their surname was proscribed (forbidden) by King James VI of Scotland (James I of England).[35] During the proscription, which lasted until 1675, MacGregor men were hunted with bloodhounds, and women's cheeks were branded with a red-hot iron. To survive, the clansmen resorted to cattle rustling and poaching deer. Persecution continued until 1774.

In the early eighteenth century, the outlaw Rob Roy MacGregor, sometimes known as the Scottish Robin Hood, became a legend in his own time when Daniel DeFoe wrote a fictionalized biography that earned Rob Roy a pardon from King George I just before he was to be transported to the colonies. Rob Roy has been the subject of a novel by Sir Walter Scott, a poem by William Wordsworth and several movies.

By the sixteenth century, some members of the Gregor clan had moved to the less turbulent Lowlands near Aberdeen, where Gaelic was not spoken. They dropped the Gaelic "mac" and adopted "ie" to indicate "son of" Gregor.

The Lowland Gregories were a distinguished family. The Reverend John Gregorie and his wife, Janet Anderson Gregorie, were remarkable in every sense of the word. Mrs. Gregorie was a mathematician in her own right and educated her talented sons in that science. In 1647, she received a large inheritance, most of which was used to establish a school for the education and maintenance of orphans; the school continued in existence until 1884.

The Lowland Gregories did not escape intrigue and retributions. John Gregorie loaned a substantial sum of money to Francis Crichton. Instead of satisfying the debt, in 1664 Crichton murdered John Gregorie's oldest son

Kinardy Castle, the Gregorie ancestral home near Aberdeen, Scotland. *Courtesy Sarah Gregorie Miller.*

and heir, Alexander Gregorie. The unfortunate Alexander was ambushed, severely wounded and kept prisoner for three weeks. On a cold and stormy morning, his abductors dragged the still-bleeding man out of bed, flung him across a horse and took him to an even more remote hideout. Alexander was rescued and taken to Aberdeen, where he died.

John Gregorie's second son, David, inherited his father's estate and was known for living ninety-five years and for siring twenty-nine children. David Gregorie invented a piece of artillery that Sir Isaac Newton declared "tended only to the destruction of the human race." Newton's assessment caused the invention to be destroyed, but because Gregorie still wanted to test his artillery, in spite of his age, he almost joined Marlborough's army in Flanders. David Gregorie owned the first barometer in north Scotland.

Another of John Gregorie's talented sons was an astronomer who invented the reflecting telescope. A respected professor at Edinburgh University, James Gregorie was struck with blindness and died of a stroke at age thirty-seven just after showing his students the satellites of Jupiter.

David Gregorie's children also enjoyed distinction. His namesake, another David, was a genius who was appointed the first professor of mathematics at Edinburgh University upon his graduation at age twenty-two. He later went on to Oxford, where Sir Isaac Newton considered him to be the greatest mathematician in all of Scotland. It is from this line that Gregories emigrated from Scotland to the American colonies in the eighteenth century.

Colonial Gregories

As was the custom of the day, in 1757 the son of still another James Gregorie was sent to Dumfries, Virginia, at age seventeen to be trained in a "colony of Scots" engaged in the mercantile business. He was quite successful; he married and returned to England in 1775 with his wife and children to attend to some family business. He left his oldest son, Alexander, in Virginia.

Because of the Revolution, James Gregorie was unable to return to the colonies until 1780. He arrived by himself in Charleston and became a citizen in 1783. He established a successful mercantile business, importing from the East Indies for wholesale and retail trade. After the war, his wife, three children and mother-in-law set sail for Charleston; they were tragically lost at sea when the *Earl of Galloway* sank in 1784. That same year, Gregorie was one of the seventy merchants who founded the Charleston Chamber

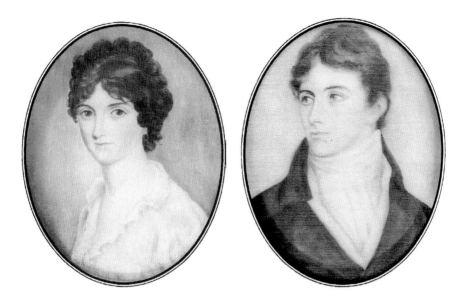

Miniatures of Anne Gibbes Ladson Gregorie and James Gregorie II. *Courtesy Sarah Gregorie Miller.*

of Commerce. He served on the board of the Bank of South Carolina, was one of the incorporators of the Charleston Insurance Company and was a member of the St. Andrew's Society. He engaged in planting and had quite a number of slaves.

Gregorie was a participating member of First (Scots) Presbyterian Church, where the story of his highly productive life is carved on a weathered tablet now embedded in the south wall of the churchyard. It reads:

> *Near this stone rest the remains of JAMES GREGORIE, Esq., a native of Scotland but resident in America for near fifty years and for upwards of twenty an eminent merchant of this city, where he lived esteemed and beloved by his fellow citizens. He was a member of this Presbyterian Church and for many years an active and useful elder and a constant attendant on all its sacred services. Being in an ill state of health, he was on his passage to New York when attacked by the last grand enemy of mankind, and in peace yielded his soul to the hands of his merciful creator on the 11th July 1807, in the 67th year of his age.*
>
> *His affectionate widow and two surviving sons have erected this stone to his memory.*

Also to the memory of MRS. THEODOSIA ROSS, her daughter Mrs. ANN GREGORIE: and ANN, ELIZABETH, and THEODOSIUS, children of JAMES and ANN GREGORIE who perished at sea in the ship Earl of Galloway on their passage from London to this place in the year 1784.

Gregorie memorial tablet by Dr. Anne King Gregorie. *Courtesy Sarah Gregorie Miller.*

The elder son, Alexander Gregorie, later joined his father in business in South Carolina and was the patriarch of one line of the family.

James Gregorie's second surviving son, also named James, came to Charleston after being educated in Scotland and touring abroad. He married Anne Gibbes Ladson in 1801 and carried on his father's mercantile tradition. In addition to exporting cotton, he had varied interests and developed an ever-bearing strawberry on his Wando plantation. As editor of the *Southern Agriculturist*, he wrote about cotton cultivation and experiments in hillside terracing developed on his plantation near Greenville. It was his children who lived through the tumultuous times of the War of Secession and its aftermath.[36]

Confederate Generation

Ferdinand Gregorie was born in his family's summer home on Sullivan's Island in 1819. The youngest of a large family, his mother refused to send him to school and taught him herself. She died fourteen years later, and Ferdinand went to work in a counting house, where he became the head bookkeeper at age eighteen. In spite of his lack of formal education, he was a talented and articulate man who was sometimes called upon to write speeches for his friends in the state legislature.

Gregorie was trained in commerce and became a merchant in Charleston and Cheraw. Before the war, Cheraw was the largest cotton market between Georgetown and Wilmington and boasted the largest bank in South Carolina outside of Charleston. Gregorie was a respected member of the East Cooper community. He was three times intendent (mayor) of Mount Pleasant and was one of the committee of gentlemen who surrendered the town to the controversial, one-legged Union general Dan Sickles in early 1865.

In appearance, Ferdinand Gregorie was almost six feet tall, with brilliant dark eyes; in his day, he was considered the handsomest man at the exclusive St. Cecilia balls. According to his granddaughter, he had one sad fault: a weakness for intoxicants, something that was common to the times. Like his forebears, he was an inventor who made an implement for sharpening saws and almost completed a self-coupling device for railroad cars. His family loved him dearly and was very supportive during the dark days of Reconstruction.

Anne Lucas Venning Gregorie and Ferdinand Gregorie. *Courtesy Sarah Gregorie Miller.*

In 1844, Ferdinand Gregorie married an heiress, Anne Lucas Venning. She was a petite, vivacious young woman with a high-strung, excitable temperament. Before her marriage, she had many suitors, some of whom left notes in her secluded Jassemine Bower.

Their early married life was spent on a Wando River plantation in the winter and in Mount Pleasant during the summer. They later sold the Wando plantation and purchased Myrtle Grove from Anne's brother, Nicholas Venning. Both Gregories had sensitive ears for music, and their home was the musical center of the community. Ferdinand played several instruments, notably the violin, and was the organist of St. Andrew's Chapel.

When war broke out, Ferdinand was exempted from active service due to a childhood foot injury that prevented him from being able to march. He served in the Coast Guard and was stationed at Bull Island and McClellanville. When he was absent from home, a faithful sixteen-year-old slave was armed to protect the family.

To escape the Union bombardment, in 1863 Gregorie took his wife, seven children and seven favorite house slaves to Clinton. After three years of war, the railroads were so disorganized that it took an entire day to load the throng of soldiers and refugees. In spite of three engines, the overcrowded train took more than twenty-four hours to make the 175-mile journey.

Gregorie returned to duty once his family was relocated. The uprooted children would not eat food that was not seasoned with salt. The commodity had been produced at Myrtle Grove by evaporating sea water on their beaches and boiling the brine to crystallization. Sloops stopped at the plantation pier, picked up barrels of salt and sent them to Clinton, where salt was used as a medium of exchange for all necessities.[37]

After the war, Gregorie and his family returned to Mount Pleasant. The village was ruled by a U.S. provost marshal and was occupied by the Fifty-fourth Massachusetts Volunteers, recognized today for their assault at Battery Wagner on Morris Island. Into their midst, the Philadelphia Friends Association for the Aid and Elevation of the Freedmen sponsored a teacher to educate the children of former slaves. Her animosity toward the defeated is exhibited in a letter to her mother:

> *Yesterday I visited Mount Pleasant with a view to moving there…It was, before the war, the summer residence of the Charleston Big Bugs. I think it will be much more pleasant than Charleston for a permanent residence, and it is only three miles across the harbor from Charleston. It is almost wholly inhabited by the blacks now…I would like to let the negroes have*

The ruined rail station in Charleston. *Courtesy Library of Congress.*

the land, put all the Secesh in the poor house, and keep them there till they die...I talk to them all. I like to hear them speak of their ruin... Everybody I meet likes me except the Secesh, and to have their hatred is an honor. Civil law is rankling in their veins... (Note: Secesh stands for Secessionist.)

It was a tense time, and incidents occurred. A couple named Muirhead was living on Hobcaw Plantation, which had been the site of the largest shipyard in antebellum South Carolina before wooden vessels became obsolete. The plantation was famous for its fine asparagus and spring waters. A group of prowling soldiers came onto the land and tried to lynch Mr. Muirhead. They dragged him to the oak avenue leading to his house, placed a rope around his neck and threw it over a branch of one of the trees. His life was spared only because he gave the Masonic sign and one of the officers, who was a fellow Mason, intervened.

On another occasion, after a sham election in the village, occupying soldiers took the ballot boxes to the Charleston ferry, hurrahing and beating drums along the way. As soon as the boat left the wharf, the soldiers seized a white man who was standing on the dock and tried to throw him into the water. The mêlée caused the boat to turn around, and those onboard rescued the victim from his tormentors.[38]

The most noteworthy confrontation, however, occurred at Myrtle Grove. Ferdinand Gregorie tried to recover from financial losses sustained during the war. He borrowed money to plant a cotton crop and household provisions. On February 6, 1866, the family returned to the plantation. It was a brave thing to do, for they were the only whites within fifteen miles of Mount Pleasant.

Everything went well for the first few weeks, but at the end of February regiments of Federal soldiers were sent to Mount Pleasant to await muster out of the service. Discipline was slack, and bands of soldiers from the Twenty-first Regular Colored U.S. troops roamed the countryside. As Myrtle Grove was near the village, idle soldiers came by daily. They used any pretext to look over the property, asking for a drink of water or permission to sit down and rest.

By April 6, two soldiers who were obviously drunk came through the gate and walked up to the piazza (porch) steps where Gregorie and his wife were standing and tried to enter the house. When Gregorie asked them to leave, they replied that as U.S. soldiers, they had a right to walk where they pleased. This precipitated an argument, and the intruders drew pistols. The Gregories hastened inside for protection. One of the soldiers shot at Anne Gregorie's retreating back; fortunately, the pistol misfired. Ferdinand grabbed a double-barrel shotgun that was leaning against the wall and, in spite of his wife's protests, went back outside. One soldier fired a shot and quickly ran beyond Gregorie's range. The other aimed deliberately and fired twice. Gregorie raised his gun and shot at his attacker, who ran into a nearby field, where he fell and died.

Gregorie mounted his son on horseback and sent him to Mount Pleasant to advise the military of the shooting and ask for protection. When the son did not return, Gregorie went into town himself. He went to the Fifty-fourth Regiment and was sent to the Twenty-first, where he was shuffled from one command to another. He was finally arrested at about eleven o'clock that evening. Put under heavy guard, he was taken to Charleston in an open boat during a drenching rain. He was wet and sick by the time he was locked in a cell in the octagonal tower of the city jail. He was provided no food, water or necessities for two miserable days.

The jail was a fortress-like brick building built in 1802. The cells were small and dank with barred windows and a ventilation shaft in the tower. Robert Mills had designed the building to be fireproof, so all doors, windows and staircases were made of iron. It was a grim place.

After the men left Myrtle Grove, two detachments of armed soldiers from Company A and Company H of the Twenty-first Regiment approached the house, firing volley after volley. The mob forced a worker to open the front door. One daughter was shot in the thigh during the assault. The beleaguered family sought refuge on the roof of an attached shed. The marauders forced them into the kitchen building, where they "slapped, kicked, cursed, and threatened" the helpless women and children. One soldier kicked the wounded daughter in the back as she lay bleeding on a blanket, too weak to move.

The soldiers proceeded to ransack the house, stealing anything of value and burning the rest of the contents in the front yard. They poured kerosene oil on the bedding and floor and tried to burn down the house but lost interest once they became exhausted from their excesses.

On April 10, a guard of white troops arrived and helped the family evacuate to Mount Pleasant. But the nightmare was far from over.

On April 11, a jury exculpated Gregorie from all blame in the shooting. Still in jail, Gregorie was contacted for a deposition. When it was discovered that he had been denied all necessities, friends in town hastened to tend to his needs until he was allowed to return home.

Later, Gregorie and his family were summoned to appear at a military court at The Citadel. Gregorie was exonerated. The family returned to Mount Pleasant, where the Twenty-first wanted revenge. The soldiers swore to kill Gregorie and carried out their threats at night by firing at his home from the streets. Eventually, General Clitz offered a guard of white troops, which remained until the black soldiers were removed to Morris Island.

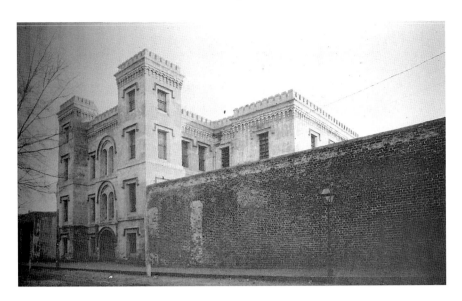

Old City Jail. *Courtesy The Charleston Museum, Charleston, South Carolina.*

The jail was a grim place.
*Courtesy Star Gospel Mission,
Charleston, South Carolina.*

General Sickles, commander of the Federal Department of South Carolina, ordered a court of enquiry to assess the damage, approved the court's findings and ordered reimbursement. Gregorie ended his narrative:

And so it remains. I have lost a crop of Cotton of 1866 to make which I borrowed $1,000. I lost a start in Life that I never have been able to make up, all of my goods & chattels, the Interest on the award of $2,000 for 13 years. The damage to my poor child whose health has been greatly impaired, and in every other way I have suffered to more than the amount of $20,000, and for what, because I was full of energy and wished to retrieve my fortunes which were ruined by the results of the war, and had to pass through a severe calamity because of the Colored Troops of the U.S. Government and their unprincipled white officers determined that the white people on the Coast should not enjoy their old Homesteads in peace, but should be forced to give them up to negroes, which has been pretty much the case.[39]

The U.S. government never reimbursed Gregorie, and because of the racial tensions, he never planted again. To support his family, he did construction work, including building St. George's Hall and restoring Christ Church, which had been used as a stable by the Union troops. A proud and sensitive man, he abruptly left a job when a carpetbagger asked him, "Don't you feel very humble, on your knees planing a floor for a Yankee?"

Myrtle Grove, a plantation of six hundred acres, was lost for a debt of about $250. The derelict house was occupied by freed slaves and later burned down. Only the oak-shrouded cemetery that Nicholas Venning bequeathed to his descendants remains. Ferdinand Gregorie died in 1880. Anne Gregorie died in 1906. They were buried in the Myrtle Grove family cemetery.

Information about the Gregories was collected by Ferdinand Gregorie's granddaughter, Dr. Anne King Gregorie. She became the first woman to receive a doctorate from the department of history at the University of South Carolina and enjoyed a long and productive career as an eminent historian, teacher and author.

The Gregorie saga parallels what happened to other families. Some traveled west to escape the harsh conditions. Three young men from Mount Pleasant decided to try their fortunes in Texas, and one agreed to go ahead to scout out opportunities. The trip was not a pleasant experience,

as an excerpt from Robert V. Royall's correspondence indicates: "Had I only known…Never again. If I get home, I'll chop wood, work in the field and live off the oyster bank." He returned to South Carolina having discovered what many southerners had learned—that religion, familial ties and social acceptability were the bedrock of all civilization. Royall, John L. Girardeau and Thomas J. Hamlin found an outlet for their adventurous spirits by riding with Hampton's Red Shirts in the election of 1876.

Union general Daniel Edgar Sickles had made quite a name for himself before he arrived in the Carolinas to command seven thousand occupying troops. Although he consorted with prostitutes, he shot and killed his wife's lover, district attorney of Washington, D.C., Philip Barton Key, the son of Francis Scott Key. In a sensational trial, he was acquitted by claiming temporary insanity brought on by the discovery of his wife's infidelity. During the war, he was friends with General Hooker, another hard-drinking ladies' man. Sickles disobeyed orders at the Battle of Gettysburg when he positioned his men at Cemetery Ridge. During the battle, a cannonball mangled his right leg. He had his leg amputated and immediately dashed to Washington to start a positive public relations campaign about his actions. The amputated leg was donated to the National Museum of Health and Medicine.

From 1865 to 1867, Sickles commanded the Department of South Carolina. He went on to serve as minister to Spain and returned to his native New York. For most of his postwar life, Sickles was chairman of the New York State Monuments Commission. In that capacity, he sponsored legislation to form the Gettysburg National Military Park; one of his key contributions was procuring the original fencing used on East Cemetery Hill. This fencing came directly from Lafayette Park in Washington, D.C. (site of the Key shooting). Principal senior generals have been memorialized with statues at Gettysburg; Sickles was the exception. Originally, there had been a memorial commissioned to include a bust of Sickles, the monument to the New York Excelsior Brigade; it was rumored that the money appropriated for the bust was stolen by Sickles himself. Sickles was finally forced out due to a financial scandal. Sickles campaigned for thirty-four years before a Congress of another generation was persuaded to award him the Medal of Honor.[40]

Map of Charleston from the 1883 City Directory. *Courtesy Middleton Papers, College of Charleston Special Collections Library, Charleston, South Carolina.*

The "Big House" at 274 Calhoun Street

The topography of the Charleston peninsula has changed radically since colonial times. Present-day Calhoun Street was once called Boundary Street. In 1769, it was laid out from Anson Street to King Street; the street was extended to the open pond at Smith Street the following year. During the Revolutionary War, the town gate was located at what is now Marion Square. The city limits remained at Boundary Street until more land was annexed in 1849.

The land bordering the Ashley River had numerous tidal creeks and expanses of marshlands. After the Civil War, some of the marsh was filled to connect Ashley Avenue, Rutledge Avenue and Smith Street with downtown Charleston. By the 1890s, there was a causeway connecting the West Point Rice Mill with Calhoun Street.

Early Entrepreneurs

After the Revolution, Jonathan Lucas Sr. invented mills that simplified the process of cleaning and milling rice. The early mills were constructed with rolling screens, elevators, packers, etc., and it was not long before efficient, automated rice mills began to dot the Lowcountry. Lucas built a rice mill on the Ashley River in the early nineteenth century that was driven by water power supplied by a pond enclosed by banks near Spring Street. This

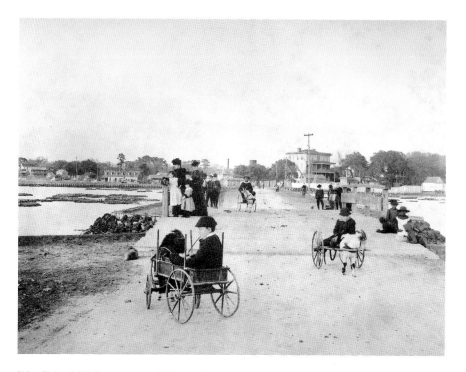

West Point Mill Causeway to Calhoun Street. *Courtesy The Charleston Museum, Charleston, South Carolina.*

mill had considerable toll business and helped Charleston achieve a highly lucrative industry that continued until thousands of acres of once profitable rice land lay dormant after the Civil War.[11]

In the early nineteenth century, lumber mills were common along the Ashley River. They derived power from the ebb and flow of the tides or from windmills. Lots bordering the low ground and marshes of Coming's Creek were acquired by Thomas Bennett Sr. and Daniel Cannon, both of whom built large water-driven lumber mills and handsome Federal homes nearby.

Daniel Cannon left his mark on the west side of the Charleston peninsula in an area now known as Cannonborough, an early suburb north of Boundary Street. Cannonborough stretched west of Coming's Creek to the Ashley River. In 1846, Henry Joseph Jackson painted two landscapes depicting east and west views of the millpond; they now hang at the Gibbes Museum of Art in Charleston. The waterfront villa beside the white house in the Jackson painting is the Cannon mansion.

Before the Revolution, Cannon prospered as a building contractor, property owner and part-time planter. He was among those who joined Christopher Gadsden under the Liberty Tree and was a member of the Congress of South Carolina in 1775. He was captain of the Cannon Volunteers during the Revolution. Cannon lived on Queen Street next door to the Dock Street Theatre and started construction of a new residence in 1802. Only the basement was completed before his death. Cannon's daughter Martha finished construction of the house, one of the finest examples of Federal architecture on the Charleston peninsula. After her death, the house was owned by a series of planters, including Henry A. Middleton of Georgetown, before it was acquired by William Gregg in 1838.

William Gregg was born in Virginia and is considered one of Charleston's outstanding entrepreneurs. Apprenticed to his uncle, he learned watch making and textile spinning in his uncle's Georgia mill. When England flooded the market with cheap imported goods after the War of 1812, the mill failed. Gregg was then apprenticed to a friend of his uncle who lived in Lexington, Kentucky.

When he was twenty-one, Gregg moved to Petersburg, Virginia, where he worked for a silversmith named Blanchard. Three years later, he moved to Columbia, South Carolina, and prospered by importing fancy goods, silver, watches and military paraphernalia. In 1829, he married Marina Jones from Edgefield.

The story is told that Gregg once went on a trip to Iowa and traveled in a coach driven by a white coachman and four horses. The cost of feed in the sparsely populated West forced him to sell two of his horses before he returned to South Carolina.[12]

Gregg turned a struggling textile factory in the Edgefield District into a highly profitable enterprise. He moved to Charleston in 1838 and went into business as a jeweler and silversmith with Nathaniel Hayden and his brother H. Sidney Hayden. Hayden, Gregg & Company became the leading supplier of luxury goods and jewelry in Charleston. The partners remained in business until Gregg devoted himself full time to the cotton industry.

A man of vision, Gregg understood the economic advantages of having mills located near the cotton fields. In 1844, Gregg toured the textile manufacturers in the North. He wrote a series of articles for the *Charleston Courier*, advocating that the South end its reliance on agriculture and start investing in manufacturing. The articles were published in pamphlet form and were widely circulated in the 1850s and 1860s through journals such as *De Bow's Review* and *Hunt's Merchants' Magazine*.

View of Charleston (View from the East), by Henry Joseph Jackson (American, 1823–1848), 1846. Oil on canvas. © *Courtesy of the Gibbes Museum of Art/Carolina Art Association, 1993.006.0018.*

By 1845, Gregg and several partners had secured a charter from the South Carolina General Assembly and established the Graniteville Manufacturing Company in the Edgefield District. The factory quickly became the most successful textile factory in the entire South. It had 9,245 spindles and a capital base sufficient to hold its own with northern competitors.[43] Gregg provided a church, library and quality housing for his workers. Medical care was available for a modest fee. He also created what is thought to be the first compulsory educational system, providing teachers and books for children from six to twelve years of age. Parents were fined five cents a day when their children were absent from classes.

Gregg was elected to the South Carolina House of Representatives in 1856, where he argued for industrial development. He was a member of the Secession Convention in December 1860 and signed the Ordinance of Secession. The Graniteville mill produced cotton cloth for the Confederacy.

After the war, the problems associated with Reconstruction brought great economic challenges to the Graniteville cotton mill. In 1867, the milldam broke. As the mill could not operate without water, during the emergency, Gregg donned hip boots and stood in waist-deep water while attempting to help repair the dam. This effort was too much for a sixty-seven-year-old

Old-fashioned floating dock. *Courtesy Middleton Papers, College of Charleston Special Collections Library, Charleston, South Carolina.*

man; he developed a severe stomach inflammation and died on September 13. He was buried in Magnolia Cemetery, mourned by his family, friends and workers alike.[14] He was inducted into the South Carolina Business Hall of Fame in 1985.

When the Greggs lived in the mansion, the house was still surrounded by water. The family used a boat for exit and entry; crabs used to nibble at the bare toes of the children when they came down to the water's edge. In the front yard were two palmettos that Mrs. Gregg had raised indoors from seed. The garden was a showplace, and drivers from the city would bring visitors to admire it. Gregg installed handsome rectangular pillars from Graniteville at the entrance to his driveway.

In 1855, Gregg sold the house to John Rutledge, son of the accomplished chief justice. The younger Rutledge married the daughter of eminent Patriot and educator, the Reverend Robert Smith, rector of St. Philip's Church, and his second wife, Sarah Shubrick. Smith was at St. Philip's Church for forty tumultuous years and is known for his active participation in the Revolution. He was the first bishop of South Carolina and helped establish the American Episcopal Church. He also started a school that later became the College of Charleston and was its first president.

Twentieth-Century Residents

When the last member of the Rutledge family who lived at 274 Calhoun Street died, it was inherited by the only living descendants of the chief justice, three daughters of Dr. Hugh Rose Rutledge of Greenville. About 1917, they came to Charleston to prepare the house for sale.

The director of Southern Collections at the University of North Carolina heard that a large cache of Rutledge papers was about to be released. Full of expectancy, he rushed to Charleston, only to find that the contents of boxes and barrels that had been stored in a damp stable for over fifty years had disintegrated into hundreds of small pieces the size of confetti. The Rutledge silver was never recovered after the war; some silver spoons and tarnished silver-plated serving dishes were left on the property and became treasures of the Anderson family, the last private owners of the mansion.

Bissell Anderson bought 274 Calhoun Street in 1919. He was descended from Scots-Irish Dissenters who emigrated from Ireland during the Great Migration of the early eighteenth century because of the religious and civil

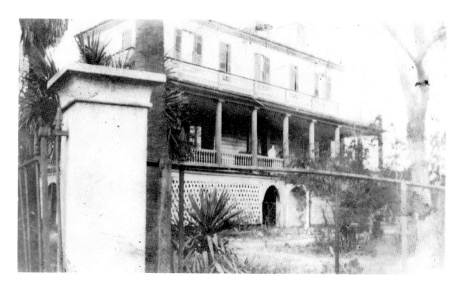

The "Big House" after the Andersons bought it. *Courtesy Anderson Papers, College of Charleston Special Collections Library, Charleston, South Carolina.*

discrimination by the English. The Scots-Irish had been excluded from the army, the militia, the civil service and seats in municipal corporations; their marriages were declared illegal, and they were not allowed to teach school.

The Scots-Irish were attracted to the religious freedoms in Pennsylvania and arrived only to discover that the original settlers did not want them and adopted restrictive measures against the new arrivals. Many Scots-Irish drifted into the Shenandoah Valley of Virginia. John Anderson, his wife and three daughters were among them. He acquired a large tract of land near Staunton and sired five sons while living in Virginia. He was an officer in the Revolution, an elder of the Old Stone Church and one of the first magistrates of Augusta County.

His progeny were outstanding citizens. Son John went to Kentucky and was a member of George Rogers Clark's expedition against Vincennes. Son James served as a captain in the Revolution. He moved to South Carolina in 1786. Son William was a captain in the Revolution and moved to Kentucky in 1784, where he was a noted Indian fighter. Son Andrew served as a captain in the Revolution and was for many years in the Virginia House of Delegates.

Robert, the oldest son, fell in love with Ann Thompson, a neighbor's daughter, shortly before he left his father's farm to survey Cherokee country in South Carolina. He was gone for two years. Ann had no communication

The "Big House" at 274 Calhoun Street

Number 281 Calhoun Street was one of the row of houses built by Anderson Lumber Company. It was later demolished, along with the house next door, to make room for a bank sited on the southeast corner of Calhoun and Gadsden Streets. *Courtesy Anderson Papers, College of Charleston Special Collections Library, Charleston, South Carolina.*

from him and presumed that he had been killed by the Indians. She consented to marry someone else. By chance, Robert heard of the impending marriage on his way back home. Hoping it was not too late, Robert spurred his horse and rode frantically to the Thompson farm. On her wedding day, as the guests were beginning to assemble, Ann looked out the window and saw young Anderson galloping up the drive. She rushed downstairs and told her maids, "Yonder comes Robert Anderson, and I love his little finger more than the other man's whole body." With that, she jumped astride Anderson's horse and rode off with him. The couple married and moved to the western part of South Carolina.

Robert Anderson was a colonel in the American Revolution and fought in some bitterly contested battles. After Cowpens, he was called "The General." He and his family lived at Westville Plantation. The General served as a judge, state representative and lieutenant governor.

General Anderson was married three times. His second wife was Lydia Maverick, widow of a prominent Charleston merchant. Elizabeth Anderson, a daughter from his first marriage, married Lydia Maverick's son, and it was their son, Samuel Augustus Maverick, who migrated to Texas. Maverick became one of the largest land and cattle owners in the world. He was a signer of the Texas Declaration of Independence, and his photograph hangs in the Texas Hall of Fame. It is said that his lackadaisical overseer failed to brand his cattle, and cowboys soon learned that when they saw an unbranded steer, it belonged to the Maverick herd, thus creating "maverick," a word that continues in our language today. A memorial plaque to Maverick now stands near the Alamo in San Antonio, Texas.

General Anderson's son, also named Robert, inherited Westville and moved there after his father's death. He raised ten children and spent much of his time in Columbia as a state legislator.

By the time of the Civil War, General Robert Anderson's great-grandson, Dr. John Anderson, was living in Charleston. Dr. John was among the pioneer dentists in antebellum Charleston and died at age sixty-six in 1886. He and his wife, Mary Caroline (Kate) Bissell, had seven children; they attended Second Presbyterian Church.

John Anderson's children were prominent members of Charleston's business community. Robert Maxwell Anderson was president of Anderson Lumber Company, president of Anderson Spool and Bobbin Manufacturing Company, president of the United States Industrial Life Insurance Company and vice-president of the State Savings Bank. He was involved in real estate and developed Colonial Street; he also built a row of houses on the

Pickens Anderson poses with two of his children in front of his residence at 281 Calhoun Street. *Courtesy Anderson Papers, College of Charleston Special Collections Library, Charleston, South Carolina.*

Ellen (Nellie) Lewis Turner Anderson standing beside Gregg's granite post.
Courtesy Anderson Papers, College of Charleston Special Collections Library, Charleston, South Carolina.

south side of Calhoun Street opposite his parents' home and segregated housing on Maverick Street. He never married.

Dr. Anderson's second son was named Titus Bissell. Born in 1862, young Bissell was forced to help support his family during the harsh Reconstruction years. In his early teens, he cut and bundled light wood at the family lumber mill. He also raised chickens and pigeons and sold their eggs; he sold the extra milk that the family dairy cow produced. His first "job" was collecting delinquent bills for Halsey Lumber Company. Bissell worked in the treasurer's office at City Hall for fifteen years and had a hauling business on the side until he went into business for himself selling building supplies. He joined Second Presbyterian Church and pumped the organ for services, weddings and funerals for a meager fee. Although he had only a high school education, he assisted his younger brothers get college degrees.

Bissell Anderson married Ellen (Nellie) Lewis Turner from Warrenton, Virginia, in 1892. Nellie had been raised Baptist, and the first Sunday she was in Charleston, she transferred her membership to the Citadel Square Baptist Church. Bissell, a member of the Second Presbyterian Church, walked up the aisle behind her and promptly joined the church, where he was an active member for the next fifty years. He taught Sunday school and sang in the choir, being paid something in the range of $100 per year. Bissell Anderson and his family were the only Baptists in the entire Anderson clan.

Bissell, Nellie and three children lived with his mother at 6 Lucas Street until his brother Maxwell built a house for him next door. In 1919, Bissell purchased 274 Calhoun Street for his growing family. The family called their new home "the Big House." They had seven children. One was killed just before Christmas 1910 when a toy cannon accidentally discharged into his right leg while he was playing in the sawdust pile of his family's lumber yard. Bissell and Nellie loved equestrian sports (tilting, racing and lancing) and owned a pair of grays and a carriage. He was a member of the Charleston Light Dragoons and was a "crack shot."[45]

Three Anderson daughters returned to the Big House when their parents began to age. Bissell died at home at age ninety in 1952, and Nellie followed him in 1959. Sister Katherine was an amateur cabinetmaker who made a grandfather clock for the stair landing, designed and made museum-quality hooked rugs for the halls and coached basketball teams at Memminger High School. Sister Alice returned from Utica, New York, with her professor husband. She taught furniture refinishing classes at the YWCA and repaired and refinished many antiques at the Big House. Sister Ellen was a social worker with the Welfare Department.

Maintaining the Big House was expensive. As their money dwindled, it became more and more difficult for the elderly ladies to live on their pensions and money from their husbands' estates. In 1979, their cousins, Dr. Robert Maxwell Anderson and Henry Miller Anderson, made arrangements to sell the Big House to the Medical University of South Carolina. Given lifetime tenancy, the sisters were relieved from the burden of ever-rising taxes and property maintenance. The two remaining sisters were already in their late eighties, and no one could foresee that both would live to be over one hundred years of age. After their deaths, the Medical College quickly converted 274 Calhoun Street into administrative offices for the School of Pharmacy.

Old-timers remember the unending mid-twentieth-century dredging that occurred before environmental legislation prohibited the destruction of wetlands. Today, the lone reminder of the millpond is a tidal lagoon between Lockwood Drive and Halsey Boulevard. With a little imagination, you can look across the water and visualize what it looked like before the Medical University dominated the skyline. Occasionally, tidal flooding makes nearby streets impassable, a reminder of how little Charleston has changed beneath the surface.

OLD-FASHIONED SUMMERS

It isn't on any Sullivan's Island map, but near Station 27 there once was a small community of summer cottages known to locals as "Andersonville." The houses were built by the sons of Dr. John Anderson, the antebellum "Mechanical Dentist" best known for a patent for false teeth, touted as an impressive technological improvement over more primitive predecessors.

In the 1890s, Maxwell Anderson acquired a lot at Station 27 from the United States government. At that time, the government owned most of the land and leased building sites for seventy-five years on the condition that the government could reclaim the land at any time. (This practice continued until 1953, when a legislative act gave clear title to the properties.) According to family tradition, the lots cost an annual fee of a dollar each, provided a two-room dwelling was built within a year.

Maxwell Anderson constructed a summer cottage for his mother, and his brother Pickens soon acquired a lot and built next door. Across the street on the "front row," Swinton Anderson quickly joined his family and built "Cabbage Patch" (named after the novel *Mrs. Wiggs and Her Cabbage Patch*).

Anderson Lumber Company barged the wood from its lumberyard located at the west end of Broad Street. Building materials were offloaded onto the beach and hauled to the lots. In time, the brothers not only built houses for their families but other houses as well. A keen eye can pick them out to this day.

Turn-of-the-century families moved to "the Island" on the first of July after school let out. It was a painstaking production. Town houses had to

be prepared to withstand moths and mildew. Laura Witte Waring wrote a charming account of her family's preparations in *You Asked for It*. Rugs were beaten and stuffed with camphor balls before wrapping them with newspapers; silver was locked away, and brasses were polished and covered to prevent tarnishing. Draperies were taken down to be cleaned; furniture was protectively covered. Summer clothing, linens, flat silver, food and animals had to be readied for the journey across the harbor. As late as the 1930s, each family had its own version of closing down the house in town.

The *Lawrence. Courtesy Anderson Papers, College of Charleston Special Collections Library, Charleston, South Carolina.*

Everybody traveled from Charleston via ferry, either the *Sappho* or the *Lawrence*. The ferry was boarded at the east end of Market Street, and twenty minutes later it landed in Mount Pleasant at the foot of Hibben Street. The boat trip has been described nostalgically as slow, relaxing, with a cool breeze blowing off the water. On rough crossings, crewmen rolled barrels full of water into the hold to stabilize the boat. Arriving passengers hurried to the waiting trolley cars, hoping to get a window seat. There were green-flagged locals and red-flagged express trolleys that rushed across Mount Pleasant, crossed the low-lying Cove Inlet causeway and finally stopped at the station just past Fort Moultrie.

Modern conveniences were still in the future. Water was hand pumped; wash basins, pitchers and chamber pots adorned bedrooms. Screens were crude, and people slept under mosquito nets. Blocks of ice wrapped in crocus sacks were placed in an icebox; a drain in the bottom let out the melted water. When the sea breezes slacked off at low tide, there was nothing except hand fans to move the still air. The ubiquitous outhouse was discreetly located as far from sight as possible.

There were wooden walkways to the stations where the trolleys dropped off the men returning from work in the city. Greeting "father" at the end of the day was a big event, and sometimes families brought wheelbarrows to push back the fresh meat and groceries carted from town to supplement what the local vendors delivered to the houses.

Families were usually large, and youngsters entertained themselves. Books were popular. Fishing, crabbing, boating, ponies and digging in the sand provided pleasant diversions. Children enjoyed simple things like rolling down the dunes and making sand castles on the beach. The favorite ritual was churning ice cream for Sunday dinner. Everyone excitedly clamored for his turn in the hope of getting to lick the dasher. Church picnics featured sack races, three-legged races and homemade kite contests. Swimming in the surf was especially tedious for the girls, who wore knee-length swimsuits, pantaloons, caps, canvas shoes and black stockings. Boys' swimwear was simpler and allowed for more freedom of movement.

The Anderson enclave did not change until the "Storm of 1911." The evening of August 29 started peacefully enough. The star-filled Saturday night sky was clear until the rains started about midnight. The barometer continued to fall throughout the night. By Sunday morning, the weather forecaster sent out an emergency advisory, with flags at the Sullivan's Island Coast Guard station, urging people to return to the mainland. It warned that due to an easterly wind, exceptionally high tides were anticipated.

Rain continued throughout the morning, but that did not deter many on "the Island" or the fifteen hundred excursionists on the Isle of Palms. Unprepared, few paid attention to the elements until the winds picked up. Most packed up and hastily left for the three o'clock ferry. Eight hundred passengers jammed onto the *Lawrence* and made the rough crossing to Charleston. Many were seasick and disembarked in wild confusion. As people hastened to get onto solid ground, the press of the crowd was so great that some women fainted, and children screamed as they were almost trampled. The faithful ferry returned to Mount Pleasant in a turbulent harbor, but once there, it was forced to discontinue service.

A group of 350 people weathered the storm at the posh Seashore Hotel on the Isle of Palms. Reminiscent of the *Titanic*, they made news the next day with a headline praising the hearty guests who had "made merry with music while the storm raged." Everyone had joined in the effort. One lady played the piano while others sang and provided recitations. With his guests occupied, the Seashore's owner, James Sottile, and several men braved the relentless, howling wind and boarded every door and window in the hotel.

Sailing was always a popular summer sport. *Courtesy Anderson Papers, College of Charleston Special Collections Library, Charleston, South Carolina.*

The hurricane of 1911 blew over the cabin next door to the Cabbage Patch. It was incorporated into the rear of the house built by T. Bissell Anderson. *Courtesy Anderson Papers, College of Charleston Special Collections Library, Charleston, South Carolina.*

On Sullivan's Island, over five hundred people "sat out the storm." Miraculously, there were no deaths. This was attributed to the heroism of the soldiers stationed at Fort Moultrie, who patrolled throughout the night. In some places, the water rose above a man's head; other parts of the island were completely submerged. Entire houses were washed away.

Tom Waring, editor of the *News & Courier*, wrote later:

> *Among my earliest memories (age four) is the big wind that rattled the windows of my family's house on Sullivan's Island. I woke in the night to frightening sounds and saw my father stuff wads of paper in the window sashes to reduce the noise. Next morning, I arose to find the yard covered with water and ducks swimming about. Chickens had drowned in their pen.* [46]

The destruction was enormous, even worse than the disastrous hurricane of 1893. Hundreds of beach properties were destroyed. The Consolidated Railway was a mass of debris from Mount Pleasant to the Isle of Palms terminal. According to a contemporary news article, in Mount Pleasant "the Consolidated car shed was unroofed, the ferry ticket office was destroyed, the ferry bridgeway washed away and a number of residences unroofed." When the death toll came in, seventeen people had lost their lives. Another

casualty of the hurricane was the demise of the three-hundred-year-old Carolina Golden Rice industry. Dykes were broken, fields were flooded with salt water and the world-renowned crops were utterly destroyed.

Like the Warings, the Andersons had decided to ride out the storm. Bissell Anderson and his family were visiting his widowed sister-in-law at Cabbage Patch on the front beach. About ten o'clock, the winds became increasingly violent, and the water began to churn as it continued to rise. Thinking it prudent to move away from the unprotected front beach, they decided to move farther back to his brother's house. The animals were released to fend for themselves, and twenty-three people braved the storm at Pickens Anderson's cottage. As the rains pounded, someone remarked, "This is just like the ark." The name stuck, and the beach house is called the Ark to this day.

The hurricane blew over the two-room house next door to Cabbage Patch. Bissell Anderson bought it and later incorporated the cottage into a large two-story dwelling that came to be known as the T.B. Anderson house.

When the Anderson clan increased, they constructed an elaborate diving platform that had to be hauled into the surf. It was a heavy, complicated affair that resembled a jungle gym. The reward for helping was the privilege of using it. Family photographs attest to the antics that the boys enjoyed as they plunged into the water.

The Andersons' diving platform. *Courtesy Anderson Papers, College of Charleston Special Collections Library, Charleston, South Carolina.*

Today the diving platform is long gone, and Cabbage Patch was torn down just before Sullivan's Island started to preserve its architectural heritage. Andersonville is only a memory, but Anderson houses remain, a lasting reminder of bygone days when old-timers entertained any who would listen to their yarns about Sullivan's Island's interesting past.

Charleston's Early Island Resorts

Due to its proximity to the harbor entrance, Sullivan's Island played a prominent role in the Carolina colony from its earliest days. It was named for an Irish lighthouse keeper, Florence O'Sullivan, who was captain of one of the first ships to arrive from England in 1670.

To prevent an epidemic, early in the eighteenth century a pest house was built on Sullivan's Island to quarantine the sick who were sent over from Charles Town. (It was moved to Morris Island after the Revolution.) In 1744, Sullivan's Island also became the quarantine point for arriving African slaves.

The island gained fame in 1776 when the colonials, under the command of Colonel William Moultrie, warded off a fleet of British warships, a victory so stunning that George Washington visited the battle site during his historic 1791 trip to South Carolina. The fort was named in Moultrie's honor and became part of Charleston's four-fort defense system.

By the 1820s, "the Island" had become a summer retreat for Charlestonians and Lowcountry planters. A town called Moultrieville evolved. It had a market, two churches, several hotels and about two hundred houses, many of which fronted the beach and provided a charming shoreline for the ships entering the harbor.

Instead of surrendering to Confederate forces, the Union garrison at Fort Moultrie stealthily evacuated to Fort Sumter on Christmas night 1860. The fort was badly damaged during the hostilities and had to be rebuilt afterward. In the 1880s, the defenses were expanded with gun embankments that extended far beyond the confines of the original fort.

After Reconstruction ended, it did not take Charleston residents long to seek out sea breezes during summer months. The elegant New Brighton Hotel was built in 1883. (The name was later changed to the Atlantic Beach Hotel.) In its heyday, it rivaled the northern sea resorts and was reputed to be the best hotel south of Norfolk, Virginia. Summer homes were gradually

built all the way up to Station 27. Only the end of the island near Breach Inlet remained a no-man's land of sand, cockspurs and scrub trees, a truly desolate place inhabited primarily by insects, snakes and the birds that scavenged at the dump.

Across the inlet was another island originally known as Hunting Island and later known as Long Island. There is a lovely tradition that when the first English settlers arrived, native Seewee Indians swam out to the ships and brought them to shore. A fanciful legend states that pirates buried treasure on the isolated island. During the Revolution, Sir Henry Clinton's grand attack on Charles Town included a rear assault on the colonials who were defending the harbor's entrance. Sir Henry's big mistake was to assume that his troops could easily ford the narrow strip of water that separated Long Island from its neighbor. Many British soldiers were lost as "Danger" Thomson's sharpshooters gunned them down in the treacherous cross currents of Breach Inlet. And almost one hundred years later, the first submarine to sink an enemy ship departed from the remote island.

In 1898, Dr. Joseph Lawrence, president of the Charleston Seashore Railroad, purchased Long Island and developed a seashore resort called the Isle of Palms (pronounced "pams" by Charlestonians).

The Seashore Railroad constructed nearly eight miles of track and a trestle over the dangerous inlet; it built a terminal on the elevated "sand hill" portion of the island near the present-day Isle of Palms business district. The August 1898 *Courier* described the trolley journey across Sullivan's Island in elegant prose: "After passing the Atlantic Beach Hotel, the Seashore Road runs through a mile or more of low and unpleasant land, myrtles, sand hills, and hollows filled with rain water, and the track had been washed in some places so much as to give cars a good shaking when passing over. The bridge across Breach Inlet is another fine piece of work and stands as solidly as a brick wall against the ebb and flow of the tide." The article went on to describe sand hills "covered with a beautiful growth of palmettos, picturesque trees that gave their name to the island."

The first passengers who arrived on the new trolley found 150 workmen busily completing construction of two large bathhouses (one for men and one for women), a dance pavilion and a restaurant. The dance pavilion was huge, 319 feet in length by 90 feet. These amenities were owned by the railroad and could be used by all passengers who purchased tickets. The pavilion and its piazza provided guests with relief from the sun.

A substantial plank walkway connected the railway station with the pavilions and the elegant beachfront hotel. Designed to rival any on the

Miss Simons enjoying an outing at the Isle of Palms. *Courtesy Middleton Papers, College of Charleston Special Collections Library, Charleston, South Carolina.*

coast, the Seashore Hotel was completed in less than two years after the resort opened. It soon earned the reputation as being the "hottest spot in town." The Seashore offered special weekend vacation trips from dinner Saturday night until Monday morning for three dollars.

The Isle of Palms amusement park. *Courtesy The Charleston Museum, Charleston, South Carolina.*

By 1912, James Sottile, an enterprising businessman from Florida, had expanded his holdings with an amusement park. The Ferris wheel was the tallest in the country and could be seen from miles away. There was a steeple chase imported from Coney Island where riders enjoyed five mechanical horses that raced around a U-shaped course. The winner got a free ride. And, of course, the park had a carousel with a brass ring.[17] Ladies dressed up in charming, filmy floor-length gowns, and the men complemented the scene decked out in their summer whites and straw hats. Concerts were featured in the afternoons. A native Charlestonian remembers her socialite grandmother reminiscing about the waltzes that John Philip Sousa played in the Isle of Palms pavilion long before he became famous for his military marches.

Villa Margherita

Once the safety of American shipping was assured after the War of 1812, Charleston began to enjoy unimaginable wealth exporting naval stores, rice and sea-island cotton. With their newfound affluence, the city fathers devised a grand scheme for a gathering place for Charleston's elite, an elegant L-shaped park that extended beyond the original walled city from Atlantic to Church Streets on the east and faced what is now called South Battery on the south. Because the shoreline was covered with oyster shells, it was known as White Point.

Before park development was implemented, the financial panic of 1837 caused the city to modify its original design. It was decided to raise the money for a somewhat smaller park by selling off land on the eastern side of the proposed project. The remaining parkland was a spacious rectangle that eventually extended all the way to King Street.

The park was laid out in the 1830s and was built up over the next two decades. It was enclosed by a waist-high wooden fence with entrances through turnstiles placed opposite King, Meeting and Church Streets. The stiles were intended to keep out cows, horses, mules and inebriates; a five-dollar fine was imposed on anyone convicted of violating an ordinance that prohibited their presence in the enclosed area. The fence and stiles were removed in 1861 when the city was fortified and earthworks were thrown up.[48]

Some of Charleston's most glorious mansions were built overlooking the harbor and fashionable White Point Garden. Although this area escaped the

South Battery under fortification. *Courtesy Library of Congress.*

fire of 1861, the bombardment that began in August 1863 forced residents to vacate the lower part of the city. Thereafter, only Confederate soldiers came to watch the burning shells come across the water. The devastating earthquake of 1886 damaged some buildings, too. In spite of those setbacks, the wedge of land at the southern tip of the peninsula remained an exclusive address. The Battery's ocean breezes and view of the harbor made this unique seaside promenade a "daily delight all the year round" to visitors and residents alike.[49]

During Reconstruction, many downtown mansions changed hands, and interesting traditions are connected with some of those sales. Located

directly across from White Point Garden, Number 20 South Battery is one of those transactions. Built in 1843 by a wealthy factor, the house was sold in 1859 to another factor, John F. Blacklock, who moved from his handsome Georgian home on Bull Street. He abandoned the house during the siege of Charleston and sold it in 1870 to Colonel Lathers, a native of Georgetown, who had gone north. Lathers had married into a wealthy New York family and made a fortune in banking, insurance and railroads.

Although he opposed the war, Colonel Lathers fought for the Union. Afterward, he tried to help revive the economy in his home state. Representing numerous northern cotton mills, Lathers brought senators, the governor of New York and financiers to Charleston to investigate business opportunities. His efforts were premature. South Carolina was still staggering from an economy that had been destroyed by a brutal war and occupation by Union troops who backed a corrupt government. Charlestonians wanted no part of "damn Yankees." Rebuffed by the locals, Lathers decided to sell his house, which he had extensively remodeled in the Victorian fashion. Andrew Simonds bought the modernized mansion in 1874.

Simonds reportedly had left some funds in Liverpool, England, instead of investing everything in Confederate bonds. He amassed a fortune by founding both the First National Bank of South Carolina and the Imperial Fertilizer Company, an enterprise that enabled impoverished plantation owners to raise tax money by strip mining their idle land for phosphate. Andrew Simonds used his spacious home for extensive business and political entertainment. He added a fleet of ships to trade from the wharves of Charleston and gave his family a privileged existence.[50]

Simonds's son and namesake married a New Orleans debutante in 1885. His bride's christened name was Margaret Rose Anthony Julia Josephine Catherine Cornelia Donovan O'Donovan, but her mother had rebelled and simply called her "Daisy." She became Daisy Breaux after her widowed mother married Colonel Gustave A. Breaux.

Born in Philadelphia, Daisy grew up in Texas and Louisiana and was educated at the Convent of the Visitation in Washington, D.C. Beautiful, spoiled and socially ambitious, Daisy found young Andrew Simonds "a gay youth, good-looking and generous with a princely manner." The carefree young couple was married in New Orleans and afterward honeymooned in Europe, accompanied by nearly the whole of the groom's family.

One of her father-in-law's many wedding presents to the newlyweds was 4 South Battery, a house located just a block east of his own oversized

Daisy. *Courtesy Charles W. Waring III.*

mansion. Facing White Point Garden, it was a pre–Revolutionary War three-story red brick dwelling in the typical "single-house" style, with wide upper and lower piazzas facing the harbor. It was one of the historic houses where Charlestonians watched the firing of the first shot of "the War" in 1861.[51]

Simonds succeeded his father as president of the First National Bank and became the country's youngest president of a national bank. To reflect his

expanding fortune, Simonds permitted his wife to demolish their existing house to make way for a mansion designed by Frederick P. Dinkelberg, who later worked with Daniel Burnham on the design of the Flatiron Building in New York City.

Daisy helped plan her new home and derived much joy in the artistic expression it afforded. The façade was pure Italian Renaissance, with four white fluted Corinthian columns across the front. It was built around an inner court with a swimming pool and garden. The interior was meticulously appointed and boasted a ballroom, a library, several reception rooms and a large dining room adorned with San Domingo mahogany wainscoting. It was a grand mansion unlike any other in the city.

The young bride enjoyed entertaining and dropped the name of almost every guest in her late-life autobiography. Her entertainments were modestly proclaimed "part of the annals of [Charleston], for it was a point of pride…never to give a stereotyped party." She gave elaborate theme costume parties, charity benefits and house parties for visiting friends and dignitaries; there were entertainments for yachtsmen, naval officers and Spanish-American war heroes who went through Charleston. Some extravaganzas were the talk of the town, and Daisy liked it that way.

Daisy and Andrew Simonds hosted President Grover Cleveland on their yacht, the *Diana*, during hunting trips around the Santee Gun Club, of which Simonds was a founding member. Simonds had commissioned the *Diana* in

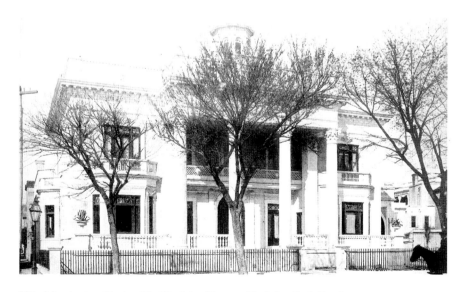

Villa Margherita. *Courtesy The Charleston Museum, Charleston, South Carolina.*

New York, specifying that it should only draw four feet so that it could ease into the Lowcountry estuaries. Daisy was usually, but not always, on such trips.

From December 1901 to May 1902, the South Carolina Interstate and West Indian Exposition was held at Hampton Park. Charlestonians went wild with enthusiasm, for the exposition made their city the showcase for the entire South. Charleston rolled out the welcome mat for President Teddy Roosevelt. No southerner had been elected president since the Civil War, and in almost forty years, only Presidents McKinley, Harrison and Cleveland had bothered to visit the impoverished Democratic South. Teddy Roosevelt was different. He was a popular Spanish-American War hero who had led southern warriors through danger and on to victory. Outside of Indian conflicts, the Spanish-American War was the first major conflict since the Mexican War sixty years earlier, when the South and North joined in a common cause.

Roosevelt's visit carried a multitude of meanings and would have been impossible a few years later, for in November 1903, he appointed Dr. William Crum, a black man, to serve as collector of customs in Charleston. Dr. Crum served in a temporary capacity through a recess appointment, but the U.S. Senate would not confirm the candidate. With his typical demagoguery, U.S. senator Ben "Pitchfork" Tillman stirred racial animosity and fueled an anti-Roosevelt atmosphere across the state. But since the exposition was before Roosevelt was on the outs, his visit created a groundswell of social activity in Charleston.

It was the custom that when a president visited a metropolitan area, he was the guest of the city. Every minute of his time was booked, and because of security concerns, it was agreed that President and Mrs. Roosevelt would not be entertained in private homes. This nicety didn't seem to bother Daisy. After sixteen years of marriage and with her husband ill, Daisy was more determined than ever to keep up appearances.

The ladies of Charleston who were members of historical societies had created the Women's Building at Lowndes Grove, a plantation located near Hampton Park. They proudly served the president tea grown in nearby Summerville.[52] Daisy made social headlines as far away as Philadelphia when she invited the "brightest women and most distinguished men in Charleston" to a select lavish luncheon served in her home.[53]

Did she really trick President Teddy Roosevelt into attending that luncheon? Charleston's favorite columnist, Ashley Cooper, quoted extensively from readers' letters, not a historical reference book, and published the following in late 1962:

Daisy could twist any man around her finger, like a pretzel…Teddy was attending the South Carolina Interstate and West Indian Exposition… Daisy, who was Chairman of the Woman's Exhibit, invited him to her house, the Villa, for lunch. The President had another engagement so he declined with thanks. But Daisy wasn't the sort to be put off…She said to him, "Well, Mr. President, at least let me give you a ride in my carriage." He accepted with thanks. And the carriage went straight to the Villa. Daisy explained to Mr. Roosevelt that she had to stop off at their house for a minute. And then she went into the Villa and told him that lunch was on the table, and the guests were assembled. By that time, he was fascinated by her, and he readily consented to stay…

Miss Martha Washington (a direct descendant of General William Washington of the Revolution) was, at the time, a secretary at the U.S. Custom House. She was a very clever and delightful person and, being a Washington, she had to be invited to the luncheon, but Mrs. Simonds felt that she was not important enough to meet the President or sit anywhere near his table… [Note: General William Washington's house was opposite the Villa on the other corner of South Battery and Church Street.] *Miss Washington was placed at a corner table far away from the President's table. Miss Martha did not like it and felt that she should have been given a more exalted seat. She made up her mind that she would meet the President. She was very popular in Charleston and delightfully witty, so she began entertaining the guests at her table, and with her vivacious stories, soon had them laughing and having a good time.*

The President noticed it… [and] *asked to be presented to her. He talked quite a while with her, and when Miss Washington walked out of the Villa, many of the guests probably thought Miss Martha was the most celebrated Charleston guest at the luncheon…* [Charlestonians] *laughed over it for many years.*[54]

Although Daisy went to enormous effort to entertain President Roosevelt, it was normal for her to interact with the rich and famous from all over the globe, a tradition that invited jealousy and snide comments from her more provincial contemporaries, many of whom lived in reduced circumstances after their family fortunes disappeared during and after "the War."

With her cosmopolitan French upbringing, Daisy had found shabby, conservative Charleston suffocating at times. As a bride, she had committed a gaffe when she went to the Broad Street Post Office, part of what was then the business district; it was considered "bad form" for a lady to be

in the commercial area that was reserved exclusively for men. She found the mature ladies dressed in black gowns buttoned up to the throat with cameos at the neck a bit behind the times. She was not properly impressed with the coveted social event of the year, the St. Cecilia Society's ball, and published a piece for the women's edition of the *News & Courier* describing it as a *"grande dame* still doing the minuet while the rest of the world was rollicking through the two-step." Well-bred Charlestonians did not like the comparison, particularly since she did not even bother to get the spelling of Cecilia right.

Andrew Simonds's high-living lifestyle of hunting, fishing and partying took its toll on his health. His first hospitalization was in Carlsbad, Germany, where Daisy, her mother-in-law and her mother-in-law's sister socialized with the nobles during his confinement. "The Cure" did not restore his health, and he continued to deteriorate. After other hospitalizations, Andrew Simonds died in a Baltimore sanatorium in 1905. Not surprisingly, Simonds lost his salary when he was forced to resign from his employment, and he had made poor speculative investments in the last years of his life. He left a heavily encumbered estate, and to her credit, Daisy sold most of his remaining assets to pay off his debts. She converted her handsome South Battery home into an upscale stopping place for wealthy friends and acquaintances who had visited during happier times. She moved to 53 East Bay and gave the house to her daughter Margaret when she came of age.

The exclusive inn was named the Villa Margherita, after Daisy's daughter. A brochure with Daisy's well-known crest at the top of the initial page described the Villa's amenities. The advertisement contained a Latin motto that was roughly translated, "If you ain't got no money, you needn't come around." The Villa was leased to Mrs. Thomas Frost and her daughter Eugenia, and Daisy ran the establishment from behind the scenes. The Villa was later run by Miss Ina Liese Dawson. Henry Ford, Alexander Graham Bell and several presidents were among its guests. Sinclair Lewis finished writing *Main Street* while staying at the Villa.[55]

Daisy's crest. *Courtesy Charles W. Waring III.*

Two years after her husband's death, Daisy found an irresistible catch in the dashing Barker Gummeré Jr., a banker known as "Warwick" or "King Maker" of New Jersey because of his political power. Introduced by mutual political friends, they met on a cruise in the West Indies. Charming to Daisy, Barker was also highly affectionate toward Daisy's Margaret, who would later speak of him as the man she considered as her real father. The couple married at the Villa and then moved to Princeton, where members of Daisy's family had been on the faculty of the university or attended since its founding. They entertained many notable dignitaries at Rosedale House, another showplace Daisy designed.

Four years after Gummeré's death, Daisy married a third time, choosing Clarence Crittenden Calhoun, a Washington attorney. She continued her role as hostess to the world's famous personages at Rossdhu Castle in Chevy Chase, Maryland, and introduced Margaret to society in her suburban Washington home in 1919. Among the guests was His Royal Highness, the Prince of Wales. C.C. Calhoun, who had won a considerable legal judgment for the Sioux Indians, was made an honorary chief named Yellow Tail. C.C. opted to sport his full headdress with his Calhoun tartan to meet the prince, an event that Daisy's daughter, Margaret Waring, would later relate with great amusement. After that royal visit, Lord Garioch, a kinsman and son of the thirty-third Earl of Mar, presented Daisy with the sword of Bonnie Prince Charlie.

Depression financial reversals later forced the Calhouns to retrench and move out of the castle into its more modest gatehouse, the only part of the "castle" that remains intact today. Circumstances were so bad that Daisy had to sell the famous sword. About that same time, she wrote her autobiography.

Daisy published her memoirs in 1930 and *Famous Recipes of a Famous Hostess* in 1945. In the late forties, she promoted her books at a Washington social given by members of the South Carolina delegation. Although an octogenarian, she still considered herself irresistible. Not content to have just one man in tow, she took the arms of two young South Carolina junior congressmen and made them escort her throughout the entire event, much to the consternation of the wives whom they were forced to desert for the evening.

Daisy returned to Charleston the year before her death in 1949. Daisy Donovan O'Donovan Breaux Simonds Gummeré Calhoun is buried in Magnolia Cemetery, but she is not forgotten. The commanding presence of the Villa Margherita makes that impossible. Charlestonians may not have

fully accepted her, but they have never stopped talking about her. Her home has been illustrated in many journals, mentioned in numerous books and was copied twice on the French Riviera, twice in California and once in Louisville, Kentucky.

The Villa was rented to the United Seaman's Service from 1943 to 1946. Families of the seamen stayed there at rates far less pricy than those of the millionaires who once stayed at the posh hotel. A cot could be had for $0.75 a night, and bedrooms cost $1.00 to $1.50; a first-class private room with a private bath rented for $2.50.

After the war, the hotel remained unoccupied until 1947. Daisy's daughter, Margaret Simonds, had married Charles Witte Waring, an attorney from an old distinguished Charleston family. Waring became trustee of the property and in 1947 leased the Villa to C.L. Leach Hotel Company from Norfolk, Virginia. Its hostelry efforts were unsuccessful. Two fires and mortgage problems forced the Villa's closing in 1953.

The lovely Villa returned to use as a single-family residence when Waring and his wife moved into the house in 1954. They renovated many parts of the Villa and focused on creating a modern kitchen. The Warings would host many memorable New Year's Eve parties in the structure built for entertaining.

In 1961, Mrs. Waring, a recent widow, applied for a demolition permit that was denied by the Board of Architectural Review. The denial of the permit expired on August 22. On August 14, Dr. and Mrs. James M. Wilson put in an offer to purchase the property. The sale had to be consummated by September 1 to save the mansion from the wrecking ball. The Wilson family has lived there since that time and, interestingly, never referred to their home as "Villa Margherita" but simply called it "4 South Battery."

WOMEN OF DESTINY

O nce the richest colony in North America, South Carolina reached its "golden age" in the years before the Civil War; Charleston was the hub of that prosperity. Afterward, the area suffered a decline that lingered for a long time. The once proud city had been battered by bombardment and enemy occupation, devastating fires, a severe earthquake, hurricanes and poverty. Many elegant homes had been defaced by crude wooden stairs that gave access to apartments of noisy tenants. Some architectural gems suffered the worse fate of being turned over to large, impoverished black families that frequently occupied but one room. In those neglected dwellings, axe blows were rained on carved mantels and wide-beamed floors. Although Charleston's aristocracy was gradually reestablishing itself in the lower end of the peninsula, slums still festered in some downtown streets.

The tiny boll weevil had greatly damaged the cotton-based economy after World War I, and cash money was scarce. City officials were interested in the income derived from property taxes and making way for commercial ventures; they were not concerned about preserving dilapidated old buildings, regardless of their historic significance. Several noteworthy mansions had been torn down in the wake of progress, and interior woodwork in others had been purchased by museums and collectors. Faced with an economic slump, city fathers viewed the automobile as a new revenue stream.

By April 1920, the uptown home of Joseph Manigault, a prosperous rice planter, was slated to be torn down to make way for a Ford dealership. This was no ordinary town house. In 1802, Manigault had acquired a

The advent of the automobile brought car lots and filling stations to Charleston's streets. *Courtesy Anderson Papers, College of Charleston Special Collections Library, Charleston, South Carolina.*

large lot on the corner of Meeting and John Streets in the newly developed Wraggsborough, a seventy-nine-acre parcel developed by his uncle, Joseph Wragg. The house was designed by his brother, Gabriel Manigault, a self-taught gentleman architect who is credited for the Charleston branch of the Bank of the United States (now City Hall), the South Carolina Society Hall and the demolished Orphan House Chapel.

Joseph Manigault's residence was one of the first houses built in the new neighborhood and was an impressive monument to the Federal, or Adamesque, style that became popular after the Revolution. Made of brick, the mansion was built over a high basement and boasted three stories plus a two-story piazza facing the garden. A graceful, freestanding staircase separated spacious rooms on each side of the central hallway. There were high ceilings with plaster medallions and intricate neoclassical relief work throughout. On the property were numerous outbuildings and a gatehouse designed to look like a classical temple.

But the house had since become a run-down slum tenement in a bad section of town with four families living on each floor. The tenants had ripped off and burned wainscoting and stair rails. Mantels were covered with grime, and walls were filthy. The interior was described as looking like a bomb had gone off in it.

When she found out about the plans for razing the building, Miss Sue Pringle Frost, Charleston's first female realtor, decided to do something

Left: Miss Sue Pringle Frost in the Manigault House with the temple gatehouse in the background. *Courtesy The Charleston Museum, Charleston, South Carolina.*

Below: The Manigault House before renovations. *Courtesy The Charleston Museum, Charleston, South Carolina.*

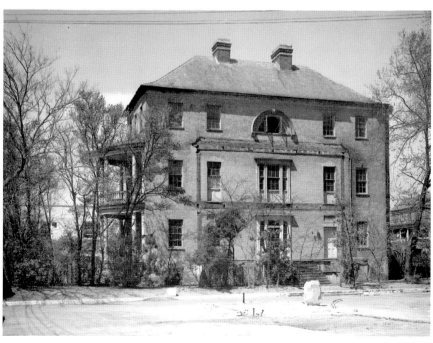

about it. Miss Sue was the daughter of Dr. Francis LeJau Frost and Rebecca Brewton Pringle and was descended from the rice planters whose plantations dotted the Santee River. She was born in the Miles Brewton House on lower King Street and had enjoyed a privileged childhood. When her father's fertilizer business failed and the family rice plantations declined, she learned stenography and entered the workplace as a stenographer for the architect Bradford Lee Gilbert, designer of the 1901 South Carolina Inter-State and West Indian Exposition, and later for the U.S. District Court. Forced to fend for herself in a patriarchal society, she became active in the women's suffrage movement, but her passion was saving Charleston's historic homes from demolition or defacing by out-of-state buyers.

In 1909, Miss Sue had already purchased two properties on Tradd Street and was deeply involved in the effort to reclaim the historic slum tenement houses along east Tradd Street, St. Michael's Alley and what is now known as Rainbow Row on East Bay Street. Always strapped for money, Miss Sue frequently borrowed—some from a family friend, Irénée DuPont, whose loans ensured that the Frost sisters gained sole ownership of their historic downtown home. A DuPont "way back" had married a Pringle, so cousin Louise Crowninshield, sister of Henry Francis DuPont, helped financially and picked up the taxes on the Miles Brewton House. With a brother avidly collecting American decorative arts for his ancestral estate, it was easy for cousin Louise to spread the word and bring paying guests to the Miles Brewton House during the tourist season.

Overextended with real estate commitments, Miss Sue urged her cousin Nell McColl Pringle to invite a group of interested friends to discuss preserving the Manigault property. Nell was married to Ernest Pringle Jr., whose mother was one of the founders of the South Carolina Society of Colonial Dames. He shared his mother's concern about Charleston's disappearing heritage and had helped her in the effort to save the colonial powder magazine located on Cumberland Street. Nell shared his passion and had helped to preserve several noteworthy buildings by getting organizations like the Chamber of Commerce to occupy them.

On the afternoon of April 21, 1920, thirty-two people met in the drawing room of the Pringle home at 20 South Battery, and that afternoon the Society for the Preservation of Old Dwellings was born. The group elected a slate of officers: Miss Sue Frost as president; Mrs. Pringle and Mrs. Moffet, vice-presidents; Miss Anne Sloan, secretary; and Miss Eola Willis, historian. As none of the ladies felt that they were good at math, Nell Pringle volunteered her husband, a banker, to be treasurer. He was to regret having to deal with

women whose bookkeeping habits were so lackadaisical that they did not bother to record checks and cash disbursements.

Nell Pringle suggested that each person pledge $1,000 for a binder to purchase the building immediately. Everyone agreed. In true Charleston tradition, having attended to the business at hand, the ladies enjoyed tea, mocha cakes and an afternoon's animated conversation. They returned home and proudly told their husbands about their accomplishments. With families to feed and tight money, the men absolutely refused to back their wives' promises. Not one single person contributed to the cause.

In the meantime, Nell Pringle, who had recently received an inheritance, advanced Sue $5,000 from her own money, assuming that $4,000 would be returned. The newly formed society purchased the Manigault House on May 19, 1920. Ernest Pringle later wrote: "In 1920, fresh from worthwhile accomplishments in war work, when my wife came to me, and gently said she wanted to risk something—and give something, but not give as much as risk—for Charleston, and its preservation, but would hold her hand if I objected, what would I say, who loved both her and Charleston."

Things did not work as planned. Without outside support, the Society for the Preservation of Old Dwellings did not have the income for taxes, a mortgage and building repairs. The Pringles began investing their personal funds to maintain the house.

Nell Pringle contacted philanthropist John D. Rockefeller, who had been instrumental in preserving Williamsburg, Virginia. Rockefeller would not talk to her directly on the phone and used his secretary as an intermediary. He told his secretary to save the place and "use it for something." Esso Standard Oil Company purchased the garden and gatehouse for $20,000. It built a filling station on its newly acquired land and converted the gatehouse into a "comfort station."

Even this assistance did not save the Pringles' personal finances. The city refused to lower taxes on the Manigault property. Nell Pringle took in tenants for a while, and Ernest Pringle was forced to sell his bank stock when the piazza fell in and the roof had to be fixed. To ease the financial burden, the Pringles converted the rear outbuilding of their 20 South Battery residence into a "motor court" known as "Pringle Court."

Getting the museum house opened became a family priority. The six Pringle children joined in cleaning up the interior, whitewashing walls and scraping the mantels before applying gallons of oil paint. While others were investing in the rising stock market, the Pringles spent their time and money working on the Manigault House, and people thought they were crazy.

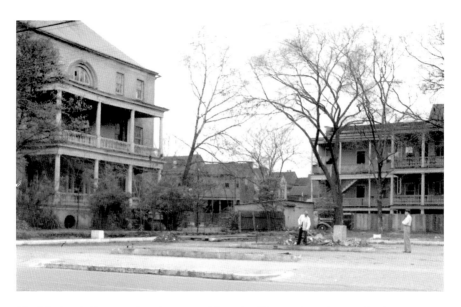

The Manigault House and garden area without the filling station. *Courtesy The Charleston Museum, Charleston, South Carolina.*

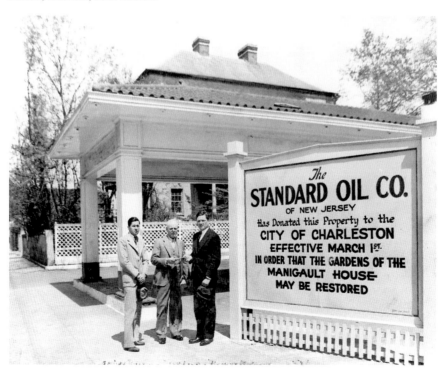

The Esso Standard Oil filling station. The Manigault House is in the background. *Courtesy The Charleston Museum, Charleston, South Carolina.*

The Manigault House opened as a house museum in the late twenties. The only tourists who came to Charleston in those days were wealthy northerners who visited in March and April. Admission fees and modest teas for local societies like the Poetry Society and the Society for the Preservation of Negro Spirituals never covered the building's expenses.

Upon the unexpected death of his father in 1922, Ernest Pringle had become president of the Bank of Charleston, which at that time had the greatest amount of assets in the state. Some bank officials complained that his vintage automobile did not match his new position. One of the proud and independent Charlestonians who have given color and charm to the city, Pringle told them that he could not afford to purchase another automobile and flatly refused an offer from one of the bank board members. When the Pringles could no longer afford to pay their chauffeur due to Depression reversals, they let him go and gave him their old car. Stubborn like his employer, the chauffeur refused to leave their employment and came to work every day *without pay.*

In 1928, rumors surfaced that a Midwestern museum wanted to acquire the architectural elements of the Heyward Washington House, and local residents were finally forced into thinking about preservation. The house had been the home of Thomas Heyward Jr., signer of the Declaration of Independence. President George Washington had stayed there during his 1791 visit to Charleston.

Built in 1771, the building had enjoyed a long and prominent history. Once the British captured Charles Town during the Revolution, Heyward and his brother-in-law, George Abbott Hall, were among the political prisoners exiled to St. Augustine, Florida. Heyward's wife and sister-in-law remained in town. Resolute Elizabeth Matthewes Heyward refused to put candles in the windows to celebrate the British victory at Guilford and again refused to illuminate for the anniversary of British occupation. Both times, the heavily shuttered house was mobbed by angry citizens. Her sister Lois Hall is remembered for having died in childbirth during the second assault. Shortly after the house was rented for President Washington's visit, John Faucheraud Grimké, a Revolutionary War hero and distinguished jurist, purchased it. Two of his daughters, known as "the Grimké sisters," became pariahs in Charleston for their strident stance against slavery in the 1820s. The house became a boardinghouse that Elizabeth Hervey, widow of Tobias Cambridge Trott, inherited some years later; she was forced to vacate during Union bombardment. Trott family tradition states that it was occupied by Union troops during

Reconstruction. Henry Fuseler converted the ground floor into a bakery in the late nineteenth century.

Because of Washington's visit, the Society of the Cincinnati (descendants of Continental army officers) contributed to the cause, and money poured in from elsewhere. In 1928, the Society for the Preservation of Old Dwellings acquired a six-month option on the Heyward Washington House. Nell Pringle felt that people had betrayed her and went into a depression that affected her delicate health.

Early in 1933, when unanticipated financial reversals meant that Ernest Pringle could no longer carry the Manigault estate, the mortgage was foreclosed. The Pringles lost $51,277, a fortune in those days. That same year, The Charleston Museum made a down payment on the Heyward Washington House, which became the society's headquarters.

Through the efforts of Milby Burton, in May 1933 the Manigault House was purchased at auction for $3,001 and given to the Charleston Museum by an anonymous donor. Upon her death, the donor was revealed to be a Beaufort native who had inherited the Hartford (A&P) fortune. Today, visitors will see a bronze plaque on the front piazza placed in memory of her mother, Mary Guerard Butler. The widowed benefactor later married an Italian prince and is remembered as Princess Pignatelli.[56] The Pringle family are said to have "remained forever haunted by the irony of a property dedicated as a memorial, not to the indefatigable Nell Pringle, but to the heir to one of the greatest grocery chain fortunes in U.S. history."[57]

Charleston experienced a cultural renaissance in the mid-twenties. In 1925, DuBose Heyward wrote *Porgy*, a story that immortalized lower Church Street; Heyward and Ira Gershwin wrote the popular opera *Porgy and Bess*. Local artists and writers took up the cause. Author Mrs. St. Julien Ravenel was interested in old houses dating all the way back to Rebecca Motte. Elizabeth O'Neill Verner and Alfred H. Hutty depicted scenes of city life in early twentieth-century Charleston.

In 1931, the Society for the Preservation of Old Dwellings was instrumental in persuading Charleston City Council to enact a zoning ordinance that created the nation's first historic district zoning law. The city established the Board of Architectural Review and designated a 138-acre "Old and Historic District," located south of Broad Street.

Nell Pringle summed it up nicely, stating that Charleston of the twenties had been capitulating on preservation matters because it had been "lulled into contentment by money in her hands, by moving pictures, jazz, and motors."

Driving through town. *Courtesy Anderson Papers, College of Charleston Special Collections Library, Charleston, South Carolina.*

Edward Twig was less kind in his sensational article "The Great Myth" published in *Forum Magazine*: "There is no such place as the utterly beautiful, charming, gracious old city that the romantics, the wishful thinkers, the fablists say there is. Remote from that great day of hers is the real Charleston—poor, uncourtly, apathetic, and having as little to do with her own brilliant past as she has with the American present." He went on to mock the local preservationists who were motivated primarily by tourist trade dollars. Miss Sue alone escaped his sharp pen.

In addition to her passion for saving old buildings, Miss Sue advocated zoning to preserve old ironwork and woodwork. She served as zoning monitor on the Board of Adjustment in the 1940s and campaigned extensively about preservation goals and needs. Friends considered her a bit eccentric. She died in 1960 and is buried in Magnolia Cemetery. She has since become an icon in Charleston's preservation movement. As she observed, "Our work and burden are tremendously increased by the fact that we not only have to fight those from the outside, but even those of our own household, from within, if we are going to save the great beauty of our city."[58]

Preservation has come a long way since that fateful day in 1920 when a handful of Charleston ladies decided to get involved.

Notes

PREFACE

1. Rivers, Eastman and Rivers, *Mendel and Me*, 46.

THE BARBADIANS

2. Ravenel, *Eliza Pinckney*, 76–77.
3. McCrady, *Under the Proprietary Government*, 327–28.

FOUNDING MOTHERS

4. Williams, *Plantation Patriot*, 33, 69–70, 131.
5. Ravenel, *Eliza Pinckney*, 1–8, 29–32, 58–69, 102–4.
6. McCrady, *Under the Royal Government*, 267.
7. Ravenel, *Eliza Pinckney*, 130–36, 164–66.
8. Ravenel, *Charleston the Place and the People*, 276.
9. Ravenel, *Eliza Pinckney*, 299–300.
10. Smith, *Dwelling Houses of Charleston*, 99–102.
11. Ellett, *Women of the American Revolution*, 68–77; Ravenel, *Eliza Pinckney*, 299–300.

12. Haw, *John and Edward Rutledge*, 257–58.
13. Rhyne, *John Henry Rutledge*, 12, 14, 89–93.

SONS OF LIBERTY

14. Fraser, *Patriots Pistols and Petticoats*, 54.
15. McCrady, *Under the Royal Government*, 725–28.
16. Steedman, "Charleston's Forgotten Tea Party," 244–59; Walsh, *Charleston's Sons of Liberty*, 58–61.
17. Stockton, *James Brown House*, 16–31, 44–51.

THE DUELLO

18. FitzSimons, *Hot Words and Hair Triggers*.

POLITICS AND PRIDE

19. Edgar, *South Carolina Encyclopedia*, 346–48, 363.
20. *South Carolina Historical and Genealogical Magazine* 32 (January 1931), 1–2, 27.
21. Edgar, Bailey and Watson, *Biographical Directory*, 335–36.
22. Ibid., 259–62.
23. Godbold and Woody, *Christopher Gadsden and the American Revolution*, 179–88.
24. McCrady, *South Carolina in the Revolution*, 304–8.
25. Godbold and Woody, *Christopher Gadsden and the American Revolution*, 179.

MEN OF VALOR

26. Hagood, *Memoirs of the War of Secession*, 208.
27. Porter, *Led On!* 236–37.
28. Bowers, *Tragic Era*, v–vi.
29. Williams, *Hampton and His Red Shirts*, 370–71.

The Promise

30. Trott Family Papers.
31. Emilio, *Brave Black Regiment*, 98.
32. Trott Family Papers.
33. Stevens, "Delayed report," 14:633.

Assault on Myrtle Grove

34. Edgar, *South Carolina Encyclopedia*, 847–48.
35. Bain, *Clans and Tartans of Scotland*, 11, 180.
36. Surles, "Surnamed Gregorie."
37. Gregorie Family Papers, 1254.02.01.
38. McIver, *History of Mount Pleasant*, 82–85.
39. Trott Family Papers.
40. From the *Encyclopædia Britannica*, eleventh edition, a publication now in the public domain.

The "Big House" at 274 Calhoun Street

41. *Year Book—1883*, 436–37, 466–67.
42. Burton, *South Carolina Silversmiths*, 220–21.
43. Edgar, *South Carolina*, 280.
44. Edgar, *South Carolina Encyclopedia*, 405.
45. Yates and Anderson, *Forebears and Descendants*.

Old-fashioned Summers

46. Anderson Family Papers.
47. Smith-Miles, "Hurricane" and "From the Past."

Villa Margherita

48. Sparkman, *Through a Turnstile into Yesteryear*, 1–2.
49. *Year Book—1880*, 102–4.
50. Poston, *Buildings of Charleston*, 268.

51. Leland, "Villa Margharita."
52. Allen, "Charleston's Women Shone."
53. *Philadelphia Sunday Press*.
54. Ashley, "Doing the Charleston."
55. Breaux, *Autobiography of a Chameleon*, 73, 186–92.

Women of Destiny

56. Holton, "Tea and Talk"; Hart, "As I Remember"; and Poston, *Buildings of Charleston*, 612–13.
57. Bland, *Preserving Charleston's Past*, 128.
58. Ibid., 128–30.

BIBLIOGRAPHY

Allen, Jane E. "Charleston's Women Shone at Exposition." *News and Courier,* n.d.

Anderson Family Papers. College of Charleston Special Collections Library, Charleston, SC.

Ashley, Cooper. "Doing the Charleston." *News and Courier,* November 11, 1962.

Bain, Robert. *The Clans and Tartans of Scotland.* London: Collins, 1954.

Bland, Sidney R. *Preserving Charleston's Past, Shaping Its Future: The Life and Times of Susan Pringle Frost.* Westport, CT: Greenwood Press, 1994.

Bowers, Claude G. *The Tragic Era: The Revolution after Lincoln.* Cambridge, MA: Riverside Press, 1929.

Breaux, Daisy. *The Autobiography of a Chameleon.* Washington, D.C.: Potomac Press, 1930.

Burton, E. Milby. *South Carolina Silversmiths 1690–1860.* Charleston, SC: Charleston Museum, 1942.

Edgar, Walter. *South Carolina: A History.* Columbia: University of South Carolina Press, 1998.

———, ed. *The South Carolina Encyclopedia.* Columbia: University of South Carolina Press, 2006.

Edgar, Walter, N. Louise Bailey and Inez Watson. *Biographical Directory of the South Carolina House of Representatives.* Vol. 2, *The Commons House of Assembly 1692–1775.* Columbia: University of South Carolina Press, 1977.

Ellet, Elizabeth F. *The Women of the American Revolution.* Nashville, TN: American History Imprints, 2004.

Emilio, Luis F. *A Brave Black Regiment: The History of the Fifty-fourth Regiment of Massachusetts Volunteer Infantry, 1863–65.* New York: Da Capo Press, 1995.

Fant, J. Holton. "Tea and Talk." *Preservation Progress* (Fall 1990).

FitzSimons, Mabel Trott. *Hot Words and Hair Triggers.* Unpublished, Charleston Library Society, Charleston, SC.

Fraser, Walter J., Jr. *Patriots Pistols and Petticoats.* Columbia, SC: R.L. Bryan Company, 1976.

Godbold, E. Stanly, Jr., and Robert H. Woody. *Christopher Gadsden and the American Revolution.* Knoxville: University of Tennessee Press, 1982.

Gregorie, Anne King. Gregorie Family Papers. South Carolina Historical Society, Charleston, SC.

Hagood, Johnson. *Memoirs of the War of Secession.* Columbia, SC: The State Company, 1910.

Hart, Eleanor Pringle. "As I Remember: The Creation of the Preservation Society and the Disappearance of the Mocha Cakes." *Preservation Progress* (Fall 1990).

Haw, James. *John and Edward Rutledge of South Carolina.* Athens: University of Georgia Press, 1997.

Holton, J. "Tea and Talk." *Preservation Progress* (Fall 1990).

Leland, Jack. "Villa Margharita, A South Battery Gem." *News and Courier,* June 16, 1986.

McCrady, Edward, LLD. *South Carolina in the Revolution 1775–1780.* Norwood, MA: Macmillan Company, Norwood Press, 1902.

———. *Under the Proprietary Government 1670–1719.* Norwood, MA: Macmillan Company, Norwood Press, 1902.

———. *Under the Royal Government 1719–1776.* Norwood, MA: Macmillan Company, Norwood Press, 1902.

McIver, Petrona Royall. *History of Mount Pleasant.* Mount Pleasant, SC: Ashley Printing & Publishing Company, 1970.

New York Times. "Read The Union Signals, Mr. Lowndes Valuable Services to the Confederacy." July 31, 1892.

Philadelphia Sunday Press. "The First Great Private Entertainment Given to President in the South Since the Civil War." May 4, 1902.

Porter, A. Toomer. *Led On! Step by Step.* 100th Anniversary Edition. New York: Arno Press, 1967.

Poston, Jonathan H. *The Buildings of Charleston: A Guide to the City's Architecture.* Columbia: University of South Carolina Press, 1997.

Ravenel, Harriott Horry. *Eliza Pinckney.* New York: Charles Scribner's Sons, 1896.

Ravenel, Mrs. St. Julien. *Charleston the Place and the People*. New York: Macmillan Company, 1912.

Rhyne, Nancy. *John Henry Rutledge: The Ghost of Hampton Plantation*. Orangeburg, SC: Sandlapper Publishing Company, Inc., 1997.

Rivers, Margaret Middleton, Margaret M.R. Eastman and L. Mendel Rivers. *Mendel and Me: Life with Congressman L. Mendel Rivers*. Charleston, SC: The History Press, 2007.

Smith, Alice R. Huger, and D.E. Huger Smith. *The Dwelling Houses of Charleston South Carolina*. New York: Diadem Books, 1917.

Smith-Miles, Suzannah. "From the Past." *Moultrie News*, August 5, 1994.

———. "Hurricane." *Moultrie News*, July 27, 1994.

South Carolina Historical and Genealogical Magazine 32, January 1931.

Sparkman, Mary A. *Through a Turnstile into Yesteryear*. Charleston, SC: Walker, Evans and Cogswell, 1966, 1–2.

Steedman, Marguerite. "Charleston's Forgotten Tea Party." *Georgia Review* (1967).

Stevens, Thomas H. "Delayed report, September 28, 1865." *Official Records of the Union and Confederate Navies in the War of the Rebellion, Series I*. Washington, D.C.: Government Printing Office, 1902.

Stockton, Robert P. *The James Brown House, 54 King Street*. Charleston, SC: privately published, 1995.

Surles, Flora B. *Surnamed Gregorie: Eight Generations in Profile (c. 1510–1852)*. Pamphlet later published by R.L. Bryan Company, Columbia, SC, 1968.

Trott Family Papers. College of Charleston Special Collections Library, Charleston, SC.

Walsh, Richard. *Charleston's Sons of Liberty: A Study of the Artisans 1763–1789*. Columbia, SC: University of South Carolina Press, 1959.

Williams, Alfred B. *Hampton and His Red Shirts: South Carolina's Deliverance in 1876*. Charleston, SC: Walker, Evans and Cogswell, 1935.

Williams, Frances Leigh. *Plantation Patriot: A Biography of Eliza Lucas Pinckney*. New York: Harcourt, Brace & World, Inc., 1967.

The World [Charleston, SC]. "The Angel of Peace." September 24, 1891.

Yates, Alice Anderson, and Dorothy Middleton Anderson. *Forebears and Descendants of Dr. John Anderson 1820–1886*. N.p., April 1975.

Year Book—1880, City of Charleston, South Carolina. Charleston, SC: News & Courier Book Presses, 1880.

Year Book—1883, City of Charleston, South Carolina. Charleston, SC: News & Courier Book Presses, 1883.

About the Authors

The authors are native Charlestonians who share a common heritage and ancestry. They have collaborated to present this volume.

Margaret (Peg) M.R. Eastman was a professional guide at Winterthur Museum in Delaware and has been a consultant on preparing job documentation for regulatory compliance in highly hazardous industries. She coauthored *Process Industry Procedures and Training Manual*, published by McGraw Hill. She also coauthored *Mendel and Me: Life with Congressman L. Mendel Rivers* and wrote *Remembering Old Charleston*, both published by The History Press. She is a freelance writer for the *Charleston Mercury*.

Edward F. Good, who shared many of the stories in this book, is a neurologist who practiced in Houston, Texas, for thirty-five years. He has served as a consultant for the NASA Space Flight Center, served on the astronaut selection team and served as principal investigator on NASA's experiment to define the causes of space sickness in astronauts. He is cofounder of the Space and Underwater Section of the World Federation of Neurology. Dr. Good is co-inventor of a heart preservation device for transplantation; manufactured hyperbaric chambers for clinical medicine; and is currently involved in a project to noninvasively monitor intracranial pressure in traumatic brain injury. He was a flight surgeon in the United States Navy.